14 February 1988

[signature]

Twachtman in Gloucester
His Last Years, 1900-1902

Front cover:
John Henry Twachtman, *Gloucester Harbor*
(pl. 5). Collection of the Canajoharie
Library and Art Gallery

Back cover:
*John Henry Twachtman at the Holley
House*, c. 1900. Photograph. Collection of
the Archives of the Historical Society of the
Town of Greenwich, Connecticut

Twachtman in Gloucester
His Last Years, 1900-1902

Essays by John Douglass Hale, Richard J. Boyle, and William H. Gerdts

A loan exhibition for the benefit of
The Archives of American Art
(Smithsonian Institution)

12 May - 13 June 1987

Ira Spanierman Gallery

50 East 78th Street New York, New York 10021 (212) 879-7085

Universe/Ira Spanierman Gallery
New York

Published in the United States of America
in 1987 by Universe Books
381 Park Avenue South, New York, N.Y. 10016

© 1987 by Ira Spanierman Gallery

87 88 89 90 91 / 10 9 8 7 6 5 4 3 2 1

Printed in Hong Kong

ISBN 0-87663-526-5

Contents

Introduction 7
by Ira Spanierman

Acknowledgments 8

Twachtman's Gloucester Period: A "Clarifying Process" 11
by John Douglass Hale

John Twachtman's Gloucester Years 17
by Richard J. Boyle

John Twachtman and the Artistic Colony in Gloucester at the Turn of the Century 27
by William H. Gerdts

Foreword to the Catalogue 47

Catalogue and Plates 50
by Lisa N. Peters

Index to Reproductions 88

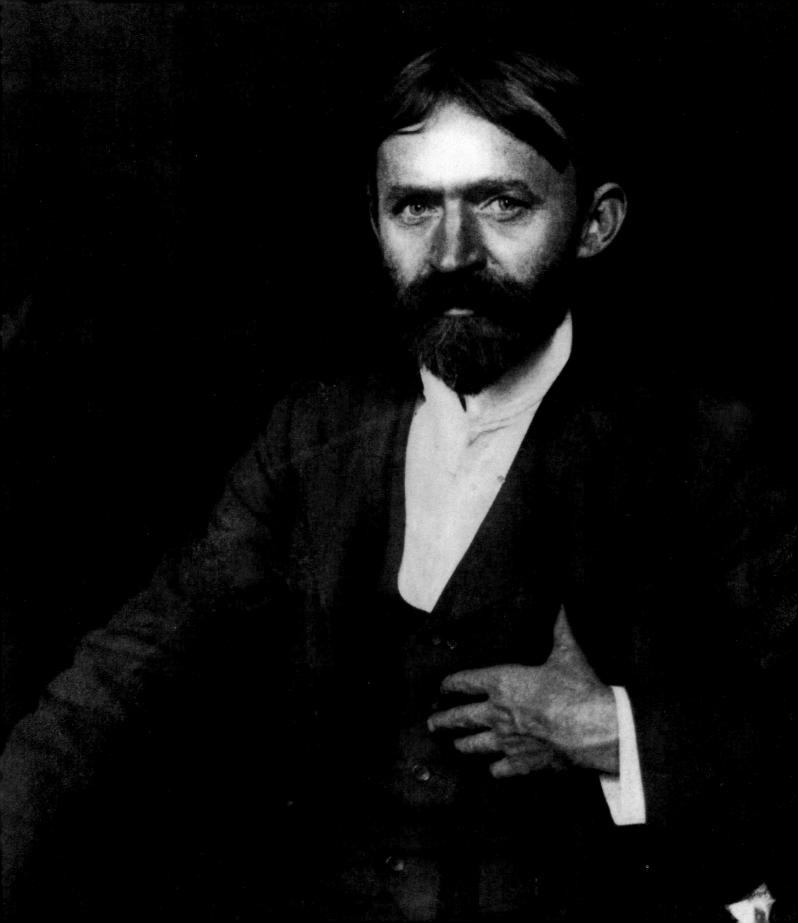

Introduction

I have felt a great affinity for the art of John Henry Twachtman since my first look at his work about forty years ago. Perhaps it was the gentle seductiveness of his vision or the way in which he seemed to probe the mysteries of distance. Twachtman's paintings don't come to me, but rather I go to them. They are paintings that make me work. At first, I didn't suspect this danger. His landscapes appeared so low-keyed, wistful, and calm. But once I was drawn in, I discovered a world of poetic and mysterious haunting beauty. Behind this attachment, there was a sympathetic passion.

Over the years I have had some adventures with John Henry Twachtman's art. About a quarter of a century ago, I bought Twachtman's *The Cascade* at a small auction on University Place. The painting had yellowed under its oxidized varnish and had faded under the accumulation of over fifty years of grime, soot, and dust. I was nevertheless excited by this coup and I phoned Ray Horowitz, at that time the only collector I knew who was keenly interested in Twachtman. He rushed over and I proceeded to clean a small "window" through the dirt and varnish. Ray was astonished, as he had never before seen a painting being cleaned in front of his eyes. Confronted by this sudden promise of great beauty, he purchased the work. Due to the generosity of Ray and his wife, Margaret, *The Cascade* is now in the collection of the Newark Museum of Art. It was an important gift which delighted Bill Gerdts, then Curator of Paintings at Newark.

In 1968, Ira Spanierman Gallery held its important John Henry Twachtman exhibition. We placed *Arques-la-Bataille*, the great masterpiece of Twachtman's French Period, on the east wall of the gallery. Although the show was not widely reviewed, word of its beauty, and particularly of the beauty of *Arques-la-Bataille*, spread quickly.

Artists came in a constant stream to admire this wonderful painting. John Howatt, the newly appointed Curator of American Art at the Metropolitan Museum of Art in New York, had the insight and perspicacity to put a "hold" on the painting. During the show, *Arques-la-Bataille* could have been sold ten times over, but happily it was soon hung just across the road at our grand old Met.

I am proud that Ira Spanierman Gallery is presenting the Gloucester paintings of John Henry Twachtman's last years. They reveal the artist's evolving comprehension of the world around him during the final years of his life.

I would like to thank Lisa Peters and the entire staff of Ira Spanierman Gallery and all of the others who have helped make this show possible.

Ira Spanierman

Opposite:
John Henry Twachtman. Peter A. Juley and Son Collection, National Museum of American Art, Smithsonian Institution

Acknowledgments

This exhibition resulted from Ira Spanierman's dedication to John Henry Twachtman's art and his recognition of the poetry and importance of the Gloucester paintings. It seeks to reveal the modernity and innovation of works Twachtman executed in Gloucester, Massachusetts, during the last summers of his life, 1900-1902, and which are so different from the quiet snow scenes he painted in the 1890s. The show was made possible by the generous loans from collectors throughout the United States. Gathered together for the first time since 1901, these works appear neither old-fashioned nor dated, but rather they are as strong, intriguing, and relevant today as when they were first painted.

I especially wish to thank Richard J. Boyle, William H. Gerdts, and John Douglass Hale for their interest in this exhibition, their counsel, and, of course, their essays. The scholarship of all three has served as inspiration during this project.

Many others provided generous assistance in the preparation of this exhibition. Martha Oaks, Curator at the Cape Ann Historical Association in Gloucester, lent her expertise and gave advice by identifying painting sites and furnishing research material. Barbara Dayer Gallati, Assistant Curator of American Paintings and Sculpture at the Brooklyn Museum offered her guidance while the show was being organized. David C. Henry, Director of the Ira Spanierman Gallery, was also instrumental both in advising me on curatorial decisions and in conferring with me at every step of this undertaking. For her superb job of editing the catalogue I am indebted to Diana Murphy; her tireless attention to questions of content and style are much appreciated. Carol Lowrey also provided valuable editorial assistance with bibliographical citations. Jolie Trager, Gallery Assistant at Ira Spanierman, diligently researched and copyedited manuscript material. Others provided help with research, among them are Joe Garland, who imparted his knowledge of Gloucester history; Adele de Cruz, who shared information on Frank Duveneck from her unpublished manuscript on the artist; Susan Walsh of the Ryerson Library of the Art Institute of Chicago, who retrieved previously unclassified material from the Library's archives; Nancy Little and Michelle Penhall of the Knoedler Galleries Library, New York, who gathered information on early Twachtman exhibitions; and Harold Bell, President of the Cape Ann Historical Association, Gloucester, Massachusetts, whose house in Gloucester stands on the site from where Twachtman painted many of his

views of Gloucester Harbor. Jean O'Hara generously provided photographs of Twachtman's Gloucester studio and related to me the history of the Harbor View Hotel. My appreciation is also extended to the staffs of the Frick Art Reference Library, New York, the Metropolitan Museum Library, New York, and the Archives of American Art (Smithsonian Institution), New York.

On behalf of the Ira Spanierman Gallery, I wish to convey my gratitude to the lenders—both individuals and museums—for agreeing to part with their paintings for this event. Many made crucial contributions in consenting to lend, arranging for a work to be photographed, and/or offering valuable research information, and they are: Edward Lipowicz, Canajoharie Library and Art Gallery; Elizabeth Broun, Andrew Connors, and Mary Kay Freedman, National Museum of American Art (Smithsonian Institution); George Neubert and Ruth York, Sheldon Memorial Art Gallery, University of Nebraska, Lincoln; Douglas G. Schultz, Susan Krane, Judith Joyce, and Laura Catalano, Albright-Knox Art Gallery; Laughlin Phillips, Willem de Looper, Joseph Holbach, Michelle Fondas, and Janet P. Dorman, Phillips Collection; Marc F. Wilson, Henry Adams, Ellen R. Goheen, and Elsie Sakuma, Nelson-Atkins Museum of Art; Robert T. Buck, Barbara Dayer Gallati, and Marguerite Lavin, Brooklyn Museum; Ellie M. Vuilleumier, Cincinnati Art Museum; Steven Rosen and Nannette V. Maciejunes, Columbus Museum of Art; Sandra Mongeon, Museum of Fine Arts, Boston; Marc Simpson and Elizabeth Boone, Fine Arts Museums of San Francisco; William Finch and Teren Duffin, Historical Society of the Town of Greenwich; Rex T. Scouten, The White House; Jean Preston, Princeton University Library Archives; Marianne Harding, Cape Ann Historical Association; Alberta Brandt, Winterthur Museum & Gardens; Jack Warner and Charles E. Hilburn, David Warner Foundation; David Findlay Jr., David Findlay Jr. Inc.; Stuart P. Feld, M. P. Naud, and Mandy Cawthorn, Hirschl & Adler Galleries; Lawrence Fleishman, Russell Burke, and F. Frederick Bernaski, Kennedy Galleries, Inc.; Alex Raydon, Raydon Gallery; Bruce C. Bachman, R. H. Love Galleries; Penelope Lagakos Turak, Lagakos-Turak Gallery; Rita and Daniel Fraad; Margaret and Raymond Horowitz; Nancy and Ira Koger; Alice and John T. Lupton; Florence and Ralph Spencer; Ralph A. Schwaikert; Sewell C. Biggs.

All members of the Ira Spanierman Gallery staff contributed in many ways to the exhibition, in particular Ira Spanierman, whose constant support and feeling for Twachtman's work allowed this effort to come to fruition.

Lisa N. Peters

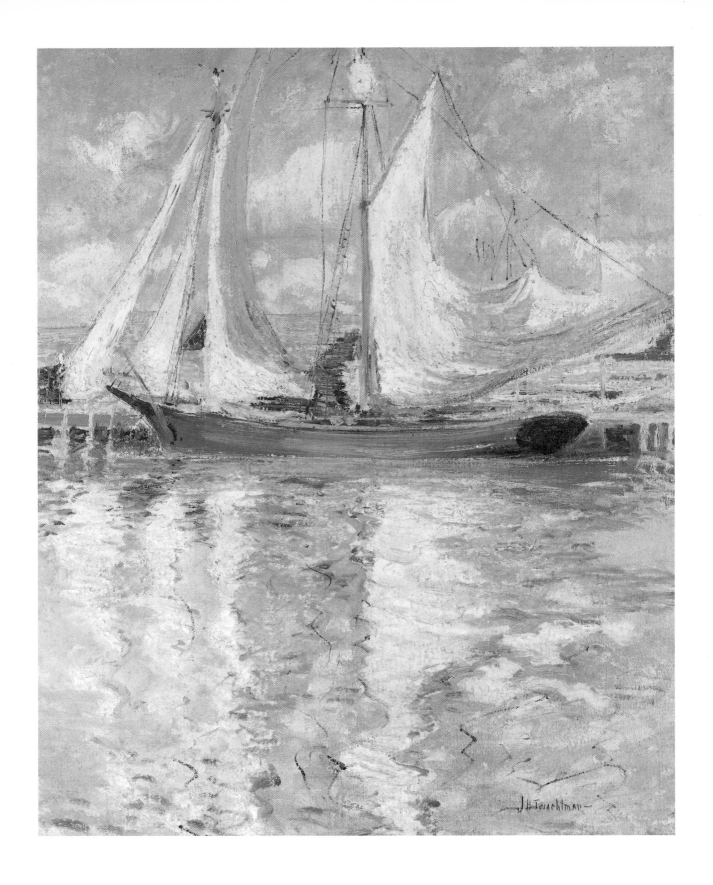

Twachtman's Gloucester Period: A "Clarifying Process"

by John Douglass Hale

John Henry Twachtman's career can be divided into five periods: the Munich, the Avondale, the French, the Greenwich, and the Gloucester. In his last period, Twachtman drew on old strengths to advance with replenished vigor in a new modern direction.

Twachtman's first period, the Munich, began in 1875 when he left his native Cincinnati, Ohio, at the age of twenty-two, for that German city. His departure was prompted by Frank Duveneck, who was his teacher at the time and would become his lifelong friend. In Munich, Twachtman was inspired by the progressive spirit that pervaded the Royal Academy, and he began to paint with dashing bravura brushwork, dark colors, and heavy, unctuous, varnish-fed impasto. This method was suitable for painting figures but not for the landscapes at which Twachtman was becoming proficient, and he came to dislike and resent his Munich training. In retrospect, he referred to the Munich palette as "black as your hat,"[1] and he felt that his drawing had been neglected during these years as well.

By 1882, when Twachtman returned to Ohio, he had carried his Munich style as far as it could go, and his Avondale style began to emerge. In this second phase of his career, a time when he painted a number of canvases in the Cincinnati suburb of Avondale, Twachtman's paint became thinner—he lightened the heavy impasto of his Munich style—although his color re-mained somber. In the Avondale paintings, he also began to organize his compositions more thoughtfully. The period was cut short, however, in 1883 when Twachtman returned to Europe—this time, to Paris—where he con-tinued his studies.

Twachtman's French Period style was the antithesis of the Munich, charac-terized by smooth and unobtrusive brushwork and by pigment washed delicately rather than stroked heavily onto the canvas. His color, although still low keyed, was no longer as dark as in the Avondale and Munich paintings. Twachtman painted many successful works in his French style, both in Europe and after his return to America in 1885. By 1889, Twachtman was living in Greenwich, Connecticut, and soon his French style came to an abrupt end. At this time, his friends Childe Hassam and Theodore Robinson returned from Europe as confirmed Impressionists, having been strongly influenced by the work of Claude Monet. It can scarcely be regarded as a coincidence that during this period Twachtman's work underwent another transformation. He realized the possibilities of using nature's hues, however, he never allowed

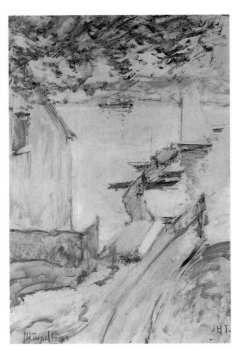

fig. 1
John Henry Twachtman, *Captain Bickford's Float*. Oil on panel, 12½ × 18⅞ in. Collection of The White House, Washington, D.C.

himself to be enslaved by the reliance of Impressionism on the translation of optical effects, often subtly modifying his color to achieve his own desired results. Twachtman felt the "influence of the students of sunlight and atmosphere; but he never gave himself up to the fascinations of 'decomposed colors' and 'vibratory' color-effects as did some of his fellows," as a *New York Times* reporter wrote in 1902.[2] His Greenwich Period style, with its debt to Impressionism, served him well for a decade, and it is the work of these years for which he is best known, especially the numerous snow scenes.

At the end of the century, at a time when Twachtman began to spend summers in Gloucester, Massachusetts, another gradual change appeared in his style that resulted in a marked strengthening of his work. In his Gloucester Period, Twachtman drew on old abilities which allowed him to create the bold works of the last years of his career. He had come to openly dispute his Munich training, yet it was the lack of color that he had rejected most, and in Gloucester he resumed the sure, confident brushwork and impasto technique he had acquired in Bavaria. In Munich, however, his paint had been oily and thick; in Gloucester, he continued to use the drier mastic turpentine of his Greenwich Period, which may be seen in the broken edges of the brushstrokes in works executed on rough canvas, such as *Fishing Boats at Gloucester* (pl. 1) and *Little Giant* (pl. 7). In *Fishing Boats at Gloucester*, the dragging brushwork is noticeable in the raised edge of the wharf in the middle foreground, which was painted with light pigment over dark, and in the rigging lines of the masts, painted with dark pigment over light. In *Little Giant*, impasto brushwork over a thin, drily brushed layer of paint conveys the bold outlines of the ferry dock and boats. Paintings such as *Gloucester Dock* (pl. 4) display a strength and confidence equal to Twachtman's Munich landscapes of the 1870s, but without the dark tonalities.

For some Gloucester works, Twachtman also reintroduced black into his palette—a radical change for one who had forsworn its use for so long. Indeed, for this reason, *Fishing Boats at Gloucester*, painted in 1900, was dated "about 1880" in Allen Tucker's 1931 monograph on the artist.[3] Whether Twachtman used black directly from the tube, or obtained it by mixing burnt umber and blue is unimportant; the appearance is the same. He was interested in the greater strength a stroke of dark color could produce, and in pursuing this Twachtman turned away from Impressionist influences, including the bias against black, which the Impressionists believed was not a color, and for this reason they tended to be puritanical about not having a tube of black in their paint boxes.

The change that occurred in Twachtman's work during his Gloucester Period did not escape the notice of New York critics. His Greenwich canvases were referred to at various times as "delicate trifles . . . to live with in peace and constantly fresh satisfaction,"[4] as having "'shy charm' . . . tender vaporousness,"[5] as well as "delicate harmony of opalescent qualities."[6] However, in writing about a Gloucester work, *Beach at Squam* (pl. 14), one critic noted that

it had "none of the oversensitiveness that occasionally weakens a landscape."[7] In 1902, another critic wrote that Twachtman's ideas had undergone a "clarifying process," his hand had become "firmer," his "art had increased in personal force,"[8] with "more subtlety and depth . . . [and] greater pictorial freedom without sacrificing accuracy and form."[9]

Did Twachtman deliberately change from his Greenwich manner of painting to his Gloucester style (as he had from his French manner to that of his Greenwich Period)? Although critics recognized the change, they saw it mostly as an improvement and a strengthening of his work. They considered it transitional rather than deliberate. In Gloucester, Twachtman derived inspiration from nature's colors, subtle or obvious, and designs configured from the collaboration of the artist's eye and the happy accidents of landscapes or seascapes that he loved. (Technical finesse was not a main concern for Twachtman during his Gloucester Period either; he had received more instruction in technique in art school than he wanted. Even his Greenwich work was mannered compared with that of his Gloucester years, when he allowed himself a new freedom with his brush.) Twachtman could have been successful continuing to paint in his Greenwich style until the end of his career. To the lay public, his painting was Impressionist, and Impressionism was becoming acceptable around the turn of the century. It would soon become respectable as well. Instead, Twachtman chose to forge ahead.

It was suggested by one of Twachtman's students that a sense of the shortness of the time allotted him drove him to paint more directly.[10] However, this seems a romantic notion, and there is evidence that Twachtman had plans for the years ahead and therefore had no such premonition. In June 1902, two months before his death at the age of forty-nine, Twachtman wrote to Josephine Holley (wife of the proprietor of Holley House in Cos Cob, Connecticut) from East Gloucester discussing his short-range plans and noting that he had "bought some frames and rented a studio."[11]

The variety and wealth of views to be found in Gloucester may have inspired Twachtman in the work of his last period. He may have been tempted by the intriguing vantage points offered by Gloucester's harbors and hills; the converging angles and radical perspectives they presented are captured in *Captain Bickford's Float* (fig. 1), *Gloucester Harbor* (pl. 5), and *View from East Gloucester* (pl. 6). He also succeeded in transferring Gloucester's diverse landscape onto canvas with a new directness, as exemplified in the simple compositions of such works as *Drying Sails* (fig. 2), *Bark and Schooner* (pl. 12), and *Harbor View Hotel* (pl. 19). Many Gloucester paintings may have been executed each in a single sitting. *Wild Cherry Tree* (pl. 11), *Captain Bickford's Float*, and *Bark and Schooner* all reveal traces of having been painted *à premier coup*.

But the Gloucester Period in the artist's development also includes works not created in that New England town. *Holley House, Cos Cob* (Collection of the Cincinnati Art Museum) is known to have been painted *à premier coup*,

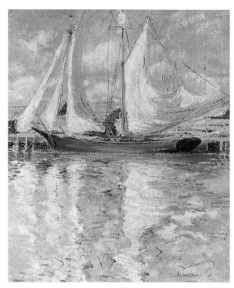

fig. 2
John Henry Twachtman, *Drying Sails*. Oil on canvas, 26 × 19 in. Collection of the Freer Gallery of Art, Washington, D.C.

and one critic had already noticed evidence of the new Gloucester style in two other paintings Twachtman exhibited in 1900, observing that Twachtman had "rarely been better represented than by 'Hemlock Pool' and, 'Brook in Winter' painted in low key color."[12]

Twachtman's Gloucester Period was the culmination of his all too short career. The power of the paintings executed during these years, however, merely reflects his development as an artist. When compared with the Greenwich canvases, the Gloucester works can appear aggressive. They are certainly the most forceful paintings he ever did. It is difficult to gauge the exact direction in which Twachtman was progressing at the time of his death in 1902. His peers, who were among the most prominent painters of the day, acknowledged, however, that at the time, Twachtman's work was in advance of his era. Thomas Dewing wrote that Twachtman represented the "most modern spirit He is too modern, probably, to be fully recognized or appreciated at present; but his place will be recognized in the future, and he will one day be a 'classic' . . . for the public catches but slowly the professional opinion, though in the end the professional opinion becomes the public opinion."[13] J. Alden Weir wrote that Twachtman "was in advance of his age to the extent that, like many others, he lived ahead of his epoch."[14] Of one thing we may be sure: Twachtman was an artist of too much integrity to have taken to the security of formula painting. Always in the vanguard of his day, Twachtman no doubt would have continued in the modern direction in which he was leading.

Footnotes

[1] Quoted in Eliot Clark, *John Twachtman* (New York: Privately Published, 1924), p. 31.

[2] "John H. Twachtman: Death of the Famous Landscape Painter at Gloucester, Mass.," *New York Times*, 9 August 1902, p. 9.

[3] Allen Tucker, *John H. Twachtman* (New York: Whitney Museum of American Art, 1931), p. 46.

[4] "Art Notes," *New York Times*, 12 April 1891, p. 12.

[5] "Art Notes," *New York Times*, 9 March 1891, p. 20.

[6] "Art Notes," *New York Times*, 4 April 1898, p. 4.

[7] "A Trio of Painters," *New York Times*, 7 March 1901, p. 8.

[8] "John H. Twachtman," *New York Daily Tribune*, 9 August 1902, p. 8.

[9] "Art Exhibitions," *New York Daily Tribune*, 2 April 1902, p. 9.

[10] Suggested by Carolyn C. Mase in "John H. Twachtman," *International Studio* 72 (January 1921): lxxiii.

[11] John H. Twachtman, East Gloucester, Mass., to Josephine Holley, Holley House, Cos Cob, Conn., 20 June 1902, Archives, Historical Society of the Town of Greenwich.

[12] "Art Notes," *New York Times*, 17 March 1900, p. 174.

[13] T. W. Dewing, "John H. Twachtman: An Estimation," *North American Review* 176 (April 1903): 554.

[14] J. Alden Weir, "John H. Twachtman: An Estimation," *North American Review* 176 (April 1903): 561.

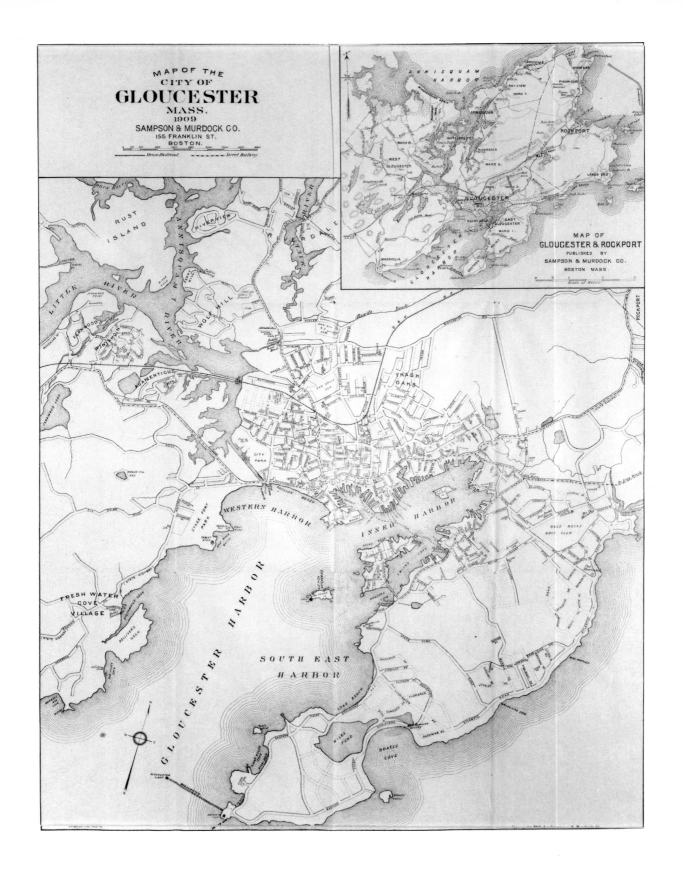

MAP OF THE
CITY OF
GLOUCESTER
MASS.
1909
SAMPSON & MURDOCK CO.
155 FRANKLIN ST.
BOSTON.

MAP OF
GLOUCESTER & ROCKPORT
PUBLISHED BY
SAMPSON & MURDOCK CO.
BOSTON MASS.

John Twachtman's Gloucester Years

by Richard J. Boyle

The bronze tablet dedicated by the North Shore Arts Association to John Twachtman was unveiled on July 15th in Gloucester, Massachusetts. . . . The tablet, simply and beautifully designed by Gertrude B. Fosdick, is placed on a boulder before the small picturesque studio where Twachtman worked.[1]

He avoided the pictorial commonplace; but he made the commonplace pictorial.[2]

By the time the notice in the *Art Digest* was published in 1934, Gloucester as an artists' colony had passed its youthful and more creative period, and the life-cycle of that aspect of the place had reached a venerable (and conservative) old age. Stuart Davis left in 1934, Edward Hopper in 1929, and there was a time when other modernists such as Marsden Hartley, Charles Demuth, and Abraham Walkowitz worked in the area. "Either the eccentrics in painting have died out or they stayed out," wrote A. J. Philpott in his review of the Gloucester Society of Artists show of 1929, ". . . it is probable that they went into retirement."[3] At the top of its cycle, however, the Gloucester painting style was Impressionist and there were almost as many artists as fishermen in the town. John Sloan, who was there from 1914 to 1918, once complained that "there was an artist's shadow beside every cow in Gloucester."[4] And in the early twenties, Charles Boardman Hawes wrote of the amazing growth of "the summer business."[5] Even in the summer of 1900, when John Henry Twachtman arrived, the Gloucester region had already been "discovered." It had been discovered by writers as well as by artists: by Edward Everett Hale, Louisa May Alcott, and Henry Wadsworth Longfellow; by Oliver Wendell Holmes and John Greenleaf Whittier; and four years before Twachtman's arrival, Rudyard Kipling celebrated the town and its fishing industry in his children's classic, *Captains Courageous*.

The first painter in Gloucester was, of course, Fitz Hugh Lane, who was a native son and whose studio still stands. Winslow Homer painted there in 1873—the year the city was finally incorporated—and again in 1880; in 1877, William Morris Hunt established one of the first open-air painting schools in this country at the village of Magnolia, a few miles from Gloucester. Frank Duveneck, Twachtman's close friend, probably spent his first summer in

Opposite:
Map of the City of Gloucester, Massachusetts, 1909. Collection of the Cape Ann Historical Association, Gloucester, Massachusetts

17

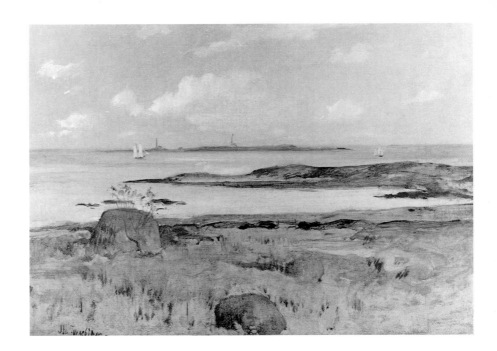

Gloucester in 1881. In 1890, he brought with him a class of art students from Boston; Helen Knowlton wrote of Duveneck and his students in the magazine the *Studio*, noting that "very strong work comes from under their umbrellas," as Duveneck held his classes out-of-doors.[6] Twachtman may have visited with Duveneck in Gloucester briefly or traveled north on his own, since it is known that before 1892 he painted a scene of the Gloucester coast with Thatcher's Island in the distance (recognizable by its two lighthouses) (fig. 1). Twachtman created an illustration after the painting, as well as another illustration of the *Eastern Side of Cape Ann* (fig. 2) which accompanied an article in *Scribner's Magazine* of June 1892.[7] The clear graphic patterns and the soft gray-green tonalities in Twachtman's depictions of Gloucester of this time reveal the continued influence of his French Period style even after his return to America from Europe in 1885. His Gloucester Period paintings, executed between 1900 and 1902, as all of the works in this catalogue demonstrate, contrast in every way with these earlier views in their bold spatial perspectives and vivid Impressionist color.

Gloucester exerted its biggest draw for artists, however, in the late 1890s, when its establishment as an artists' community became recognized. *Baedeker's United States, Handbook for Travellers* listed Gloucester as "a great resort for artists,"[8] and other major artists also came to Gloucester in the late 1890s, notably Childe Hassam and Willard Metcalf, friends and colleagues of Twachtman from the Ten American Painters group. They all painted Gloucester's inner harbor from roughly the same vantage point on the hill at Rocky Neck. At the end of the decade, William Lamb Picknell, Hugh Bolton

Jones, and Henry Kenyon gathered a group of friends from their student days in France into what Kenyon called "a regular American Pont-Aven" in Annisquam, very much in the Gloucester orbit on Cape Ann.[9] Annisquam, or "'Squam" as it was affectionately called by locals, was a popular site for artists, many of whom had studios in the area. Maxfield Parrish studied there under his father, Stephen, before they both settled permanently in the colony at Cornish, New Hampshire; and N. C. Wyeth, who was later to make Chadds Ford, Pennsylvania, synonymous with a regional tradition, studied under George L. Noyes at Annisquam in 1901. And it was around that time that Twachtman painted *Beach at Squam* (pl. 14).

Twachtman's painting *Beach at Squam* depicts a strip of the beach facing Ipswich Bay which was one stop on the tour of Cape Ann from Gloucester. While Picknell and his colleagues probably reached Annisquam by ferry from Ipswich, Twachtman would have taken the relatively new electric tram, which ran along what are now routes 127a and 127 via Rockport, Pigeon Cove, Plum Cove, Annisquam, and back to Gloucester, and "which enable[d] the tourist to visit all the points of interest . . . at a minimum of expenditure of time and money." Called "Round the Cape," the tour was a favorite outing from Gloucester.[10] *Beach at Squam* is more panoramic and open than is usual for Twachtman, an indication, perhaps, of that changing style which was noticed by the critic of the *New York Times* issue of 7 March 1901 as having "none of the oversensitiveness that occasionally weakens a landscape."[11] His Gloucester Period, so named because of this change of style, is associated with the paintings Twachtman did during summers spent in Gloucester from 1900 to 1902, and which are characterized by more vigorous brushwork, a more direct

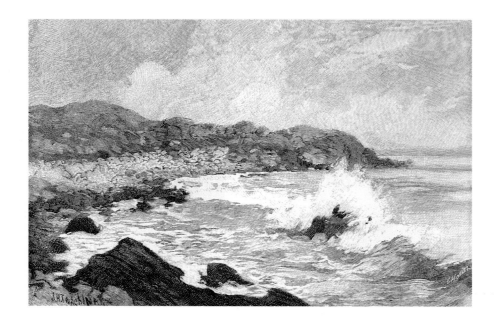

fig. 2
John Henry Twachtman, *Eastern Side of Cape Ann, Mass.* Illustrated in *Scribners Magazine*, June 1892

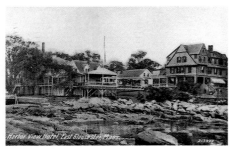

fig. 3
Harbor View Hotel, East Gloucester, Massachusetts, before 1920. Postcard. Collection of the Cape Ann Historical Association, Gloucester, Massachusetts

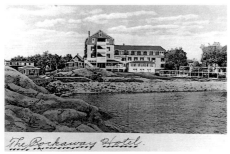

fig. 4
Rockaway Hotel, Rocky Neck, Gloucester, Massachusetts. Postcard. Collection of the Cape Ann Historical Association, Gloucester, Massachusetts

way of laying on paint, stronger value contrasts, and the reintroduction of black—or a color approximating black. Twachtman returned to the more impulsive but better controlled brushwork of his Munich Period, combining it with a sharper clarity of color. Whether Gloucester was actually responsible for the changes in his style or whether it confirmed a direction the artist was already taking is open to question. Either way the change is there and Gloucester most probably had something to do with it. The fact that there were two Gloucesters may have had a lot to do with it.

There was the Gloucester that was "a quaint and foreign-looking city" and "a great resort of artists owing partly to the picturesqueness of the town itself, and partly to the fine scenery of Cape Ann;"[12] the Gloucester that John Sloan once called "one of the odd corners of America, built against the puritan landscape, blue-eyed and rocky;"[13] the Gloucester of Shingle Style houses owned by genteel summer people and quiet resort hotels such as the Hawthorne Inn and the Harbor View Hotel in East Gloucester (fig. 3), where Twachtman stayed in 1902; and the Gloucester where paintbrush and easel competed with rod and tackle. But it was the light that was so special there; that "brilliant light,"[14] as Stuart Davis called it, and at the water's edge the light was clear and endlessly varied. This was one Gloucester.

The other Gloucester was the largest fishing port in the world, its schooners sailing up and down the East Coast from Virginia to Newfoundland and employing up to six thousand men in its fleets. It was the Gloucester about which Kipling wrote, "I had first sight of the sickening rush and vomit of iridescent coal-dusted water into the hold of a ship, a crippled iron bulk, sinking at her moorings. . . . And . . . out on a pollock-fisher, which is ten times fouler than any cod-schooner . . . I was immortally sick."[15] This other Gloucester had a deep and large harbor where Italian barks could be observed on a regular basis bringing salt for the fish processing industry, a sight that constituted the subject of one of Twachtman's finest late paintings. *Bark and Schooner* (pl. 12) was probably painted *alla prima* (all at one go), in order to capture the busyness and bustle of the active port.

Twachtman did not have to go to a summer colony for many of the reasons for which others went. Living on a farm in Greenwich, Connecticut, he did not have to escape city heat or city pressures; and as Greenwich was close to Cos Cob—where he was in the habit of going anyway—he did not have to travel very far to get to the sea. There were other reasons for going to Gloucester: the light, certainly, and the openness; the grittiness and toughness of the seaport; perhaps the different structure of the place; and, finally, the collegiality and companionship of his peers, particularly Frank Duveneck, who lived in Cincinnati the rest of the year.

One of the requirements for a successful artists' colony, besides convivial professional company, paintable subjects, and cheap living, was accessibility. Gloucester was certainly accessible, from Boston, of course, but also from New York and Philadelphia. For Twachtman to get there, he would have

boarded the New Haven, Hartford, and Springfield line at his station at Greenwich, changing at Springfield for the Boston and Albany railroad. From Boston, he would have taken the Boston to Portland line, leaving North Union station, then on Causeway Street on the Charles River across from Charlestown. After crossing the Charles, the train would have headed to Beverly, which was the junction of a branch line to Gloucester and Rockport. The trip would have taken him past Magnolia, where in Twachtman's day a handful of Penobscot Indians still camped and sold baskets; where Hunt's studio with its elevated "painting gazebo" had stood across the street from Willow Cottage; and where Louisa May Alcott wrote part of *Little Women*. Twachtman would have not seen Hunt's studio since it was gone by 1889, but his train would have past the Black Reef of Norman's Woe, immortalized by Longfellow in "The Wreck of the Hesperus." Continuing on, the train would have passed what is now Fort Stage Park, the landing site of the first settlers and fishermen who had come "to praise God and catch fish." From the station at Gloucester, Twachtman would have caught the electric tram to East Gloucester, his hotel and his studio.

Twachtman could have also traveled to Gloucester by steamboat, or "steamers" as they were called, or a combination of boat and train. Had he taken a steamer (and "their fares are usually moderate"), he could have gone by boat from New York City to Boston and on to Gloucester. Steamers from Boston also ran to Provincetown and the Isles of Shoals—both also very much associated with artists—leaving from wharves on the west side of Boston Harbor.[16] The little oil on panel *Aboard a Steamer* (pl. 16) suggests that Twachtman might have traveled at least part of the way by boat. In addition, the work is a fine example of Twachtman's Gloucester style, painted with swift and vigorous brushwork, strong contrasts of value and hue, and incorporating a color approximating black.

Twachtman arrived in East Gloucester in early June of 1900, having "secured apartments in the 'Amenity cottage,' the new Rockaway annex, for the season," as the *Gloucester Daily Times* reported.[17] The Rockaway Hotel (fig. 4) was situated on the southwest corner of Rocky Neck, an inlet off the coast of East Gloucester. In 1900, it was the major gathering place and favorite summer residence for visiting artists. The *Gloucester Daily Times* recorded the arrival of Frank Duveneck on 16 June, that of Theodore Wendel, an Impressionist painter who lived in Ipswich, Massachusetts, on 26 June, and the visit of the well-known Impressionist painter Childe Hassam, who was entertained by Rockaway guests, on 13 September. In August, the artist guests of the Rockaway held an exhibition in the parlor of the Hotel which the *Daily Times* called "the strongest from an artistic standpoint ever exhibited [in East Gloucester],"[18] and the season was summed up again by a reporter who wrote that the large number of artists staying in East Gloucester "seemed to renew the artistic atmosphere of by-gone seasons."[19] For a discussion of this exhibition, see the essay by William H. Gerdts in this catalogue.

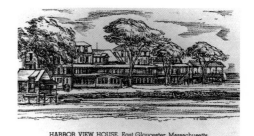

HARBOR VIEW HOUSE, East Gloucester, Massachusetts

fig. 5
Harbor View Hotel. Postcard from a pen and ink drawing by Thomas O'Hara. Collection of Jean O'Hara

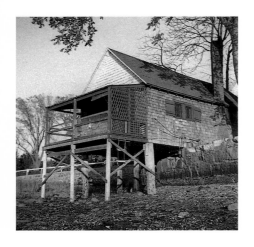

fig. 6
Views of Twachtman's Last Studio at the Harbor View Hotel in East Gloucester, Massachusetts. Photographs. Collection of Jean O'Hara

In the summer of 1901, Twachtman held art classes in Gloucester for his students from the Art Students League of New York City, where he had taught since 1894. It is likely that Twachtman again stayed at the Rockaway during this summer along with his students as the *Daily Times* reported that the "members of the Art Students League of New York, who [were] making the Rockaway their summer home, were the prime movers in one of the prettiest and jolliest costume dances ever given in the summer colony at the Rockaway."[20] However, in 1902, Twachtman established himself at the Harbor View Hotel (fig. 5), located beyond Rocky Neck along the Eastern Shore. Writing to Josephine Holley at the Holley House in Cos Cob from East Gloucester on 20 June 1902, Twachtman noted that he had "rented a studio,"[21] referring to a small two-room structure separated from the main building of the Hotel (fig. 6).[22] (The studio depicted in *My Autumn Studio* [pl. 17] may be the studio to which Twachtman refers.) Along with Joseph DeCamp, one of his oldest artist-friends also originally from Cincinnati, Twachtman again taught students from the Art Students League, holding his classes at the Harbor View.

From both his residences in East Gloucester, Twachtman sought his sites on foot, walking, studying the countryside, "inhaling nature." He "learned to know every spot, even their moods," and when he began to paint, he had already "lived through it before he began" as the painter Abraham Walkowitz recalled.[23] Twachtman often climbed East Gloucester's Banner Hill and painted the view below, looking down on the John F. Wonson Building (still

fig. 7
East Gloucester viewed from Banner Hill, c. 1903. Herman W. Spooner Collection, Cape Ann Historical Association, Gloucester, Massachusetts

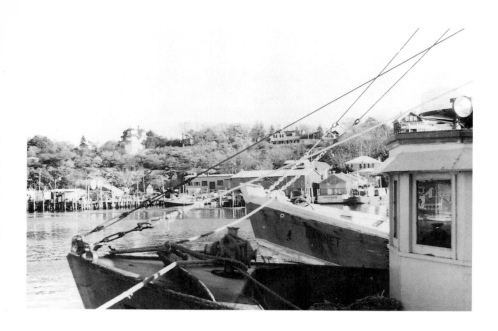

fig. 8
East Gloucester viewed from Rocky Neck,
1986. Photograph. Collection of Lisa N. Peters

standing today), and over Rocky Neck to the shore of Gloucester with its church spires beyond. A photograph taken in 1903 (fig. 7) captures the viewpoint Twachtman chose for several works in this exhibition (pls. 5, 6, 10, 11). He also painted the view from Rocky Neck for canvases such as *Fish Sheds and Schooner* (pl. 13), depicting the East Gloucester shoreline and structures on Banner Hill, many of which still exist today, as a current photograph shows (fig. 8). For other subjects, Twachtman chose less picturesque sites—fishermen's houses and dockside wharves and sheds. Painting down on the wharves, he depicted fishing boats and what Stuart Davis would call "the architectural beauty of the Gloucester schooner."[24] Twachtman often transferred his experience of Gloucester in quickly painted sketches. As Katherine Metcalf Roof wrote in 1903, many works created in Gloucester were "small impressions painted upon panels made from the lids of cigar-boxes which [Twachtman] had himself prepared for the purpose."[25] Twachtman also executed a number of crayon sketches identifying subjects and recording the basic compositions of Gloucester works. Only one of these sketches is known today, his study after *Fishing Boats at Gloucester* (fig. 9). "Looking on the decks of vessels. Gray and white,"[26] Twachtman wrote on the back of this sketch, noting his location and colors that were used.

Twachtman spent the winter of 1901-02 in Cos Cob, staying at the Holley House, while the rest of his family was in Paris visiting his son Alden, who had won a scholarship to study there. Carolyn Mase was in Cos Cob. She was a student of Twachtman and friend of the family, and she remembered how he "talked often of Velasquez—of his mastery of planes, of his color," and "how he painted that winter—with what vigor!"[27] It fits, this connection between his

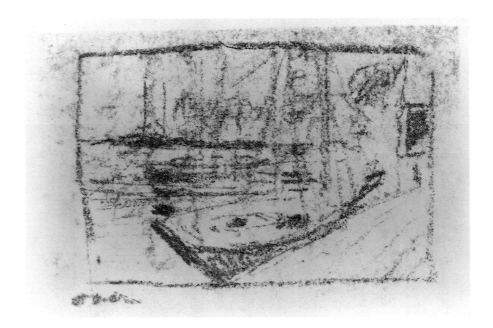

fig. 9
John Henry Twachtman. Copy of the
unlocated *Sketch after Fishing Boats at
Gloucester*

painting in stronger contrasts of value and his interest in Velásquez, and even
the renewed vigor that he carried back to Gloucester with him that last
summer. It also shows in the final picture he painted, along with his sense of
detachment and the realization of his idea in the first few brushstrokes. This
air of detachment marks him as an artist somewhat apart from his contempo-
raries, and it becomes evident if his view of *Gloucester Harbor* (pl. 5) is
compared to that of Hassam, Metcalf, or Duveneck. And it is evident in the last
painting, *Harbor View Hotel* (pl. 19) which is unfinished, but in which the idea
is fully realized. For Twachtman, landscape was not a portrait of a place as it
was for Metcalf or Hassam; rather it was a vehicle for emotion and for
contemplation. His distance was not the genteel distance of some of his
colleagues, lending enchantment to the foulness of Kipling's pollock-fisher or
cod-schooner; it was an aesthetic and philosophical detachment. The more
superficial aspects of the Impressionist style were the opposite of his person-
ality and temperament. He was a man genuinely drawn to the contemplative
life. Much of his work reveals an inner stillness and balance, suggesting that
underneath the struggle in life, there is a deeper life which continues inde-
pendent of the struggle, survives it, and is not affected by it. The stillness and
balance was analogous, perhaps, to Herman Melville's "image of the ungraspa-
ble phantom of life."[28] And this may have been one of the meanings of
Gloucester for Twachtman. Perhaps a coming to terms with himself had a
positive effect on his work, about which he wrote to his family just before he
died on 8 August 1902. "I feel encouraged," he wrote in the last letter to his
wife. "Like Heine—I see the Laurel climbing to my window."[29]

Footnotes

[1] "A Twachtman Tablet Dedicated," *Art Digest* 8 (August 1934): 18.

[2] Eliot Clark, "The Art of John Twachtman," *International Studio* 72 (January 1921): 86.

[3] Quoted in James F. O'Gorman, *This Other Gloucester: Occasional Papers on the Arts of Cape Ann, Massachusetts* (Boston: the author, 1976), p. 96.

[4] Quoted in James F. O'Gorman, "Catalogue," *Portrait of a Place: Some American Landscape Painters in Gloucester*, exh. cat. (Gloucester, Mass.: The Gloucester 350th Anniversary Celebration, Inc., 1973), p. 70.

[5] Charles Boardman Hawes, *Gloucester by Land and Sea: Story of a New England Sea Coast Town* (Boston: Little Brown, 1923), p. 212.

[6] Helen H. Knowlton, "A Home-Colony of Artists," *Studio* 8 (14 July 1890): 326. I would like to thank Adele de Cruz for generously providing material on the time Frank Duveneck spent in Gloucester from her unpublished manuscript on Duveneck.

[7] Twachtman's illustrations accompanied an article by N. S. Shaler, "Sea Beaches," *Scribner's Magazine* 11 (June 1892): 772, 775. Both were also reproduced in Shaler, *Sea and Shore* (New York: Charles Scribner's Sons, 1894), pp. 45, 53. I am grateful to Lisa Peters and Jolie Trager, Ira Spanierman Gallery, for locating these illustrations and references.

[8] *Baedeker's United States, Handbook for Travellers* (Leipzig: Karl Baedeker Publisher, 1899), p. 104.

[9] Phoenix Art Museum, *Americans in Brittany and Normandy, 1860-1910*, exh. cat., essay by David Sellin (Phoenix, 1982), p. 82.

[10] *Baedeker's United States*, p. 18.

[11] "A Trio of Painters," *New York Times*, 7 March 1901, p. 8.

[12] *Baedeker's United States*, p. 104.

[13] Museum of Fine Arts, *John Sloan: The Gloucester Years*, exh. cat., essay by Grant Holcomb (Springfield, Mass.: Museum of Fine Arts, 1980), p. 12.

[14] Quoted in James O'Gorman, "Painting at Gloucester," *American Art Review* 1 (September-October 1973): 98.

[15] Quoted in C. E. Carrington, *The Life of Rudyard Kipling* (Garden City, N.Y.: Doubleday and Company, Inc., 1956), p. 191. Carrington also noted that Kipling's chances of studying deep-sea fishermen were limited as he "paid three visits to Gloucester and one to Boston Harbor . . . all four together being no more than fourteen days," p. 180.

[16] *Baedeker's United States*, pp. 22, 81-82.

[17] "East Gloucester," *Gloucester Daily Times*, 6 June 1900, p. 3. I would like to thank Lisa Peters for retrieving material from the *Gloucester Daily Times*.

[18] "East Gloucester," *Gloucester Daily Times*, 17 August 1900, p. 6.

[19] "East Gloucester," *Gloucester Daily Times*, 1 September 1900, p. 5.

[20] "East Gloucester," *Gloucester Daily Times*, 20 August 1901, p. 8.

[21] John H. Twachtman, East Gloucester, Mass., to Josephine Holley, Holley House, Cos Cob, Conn., 20 June 1902, Archives, Historical Society of the Town of Greenwich.

[22] I am indebted to Jean O'Hara for providing photographs of the Twachtman studio where she stayed with her husband before the Hotel and studio were torn down in 1961.

[23] From John Douglass Hale's interview with Abraham Walkowitz, cited in Hale, *The Life and Creative Development of John H. Twachtman*, 2 vols, (Ann Arbor: University Microfilms, 1958), Ph.D. dissertation, Ohio State University, 1957, p. 288.

[24] Quoted in James O'Gorman "Painting at Gloucester," p. 98.

[25] Katherine Metcalf Roof, "The Work of John H. Twachtman," *Brush and Pencil* 12 (July 1903): 243.

[26] The original is unlocated. Copies of the sketch and the notes on the back of the work are in the Archives of the National Museum of American Art, Smithsonian Institution, Washington, D.C.

[27] Carolyn C. Mase, "John H. Twachtman," *International Studio* 72 (January 1921): lxxvii.

[28] Quoted in Stuart Benedict, *Literary Guide to the United States* (New York: Facts on File, Inc., 1981), p. 154.

[29] Quoted in Carolyn C. Mase, "John H. Twachtman," lxxv.

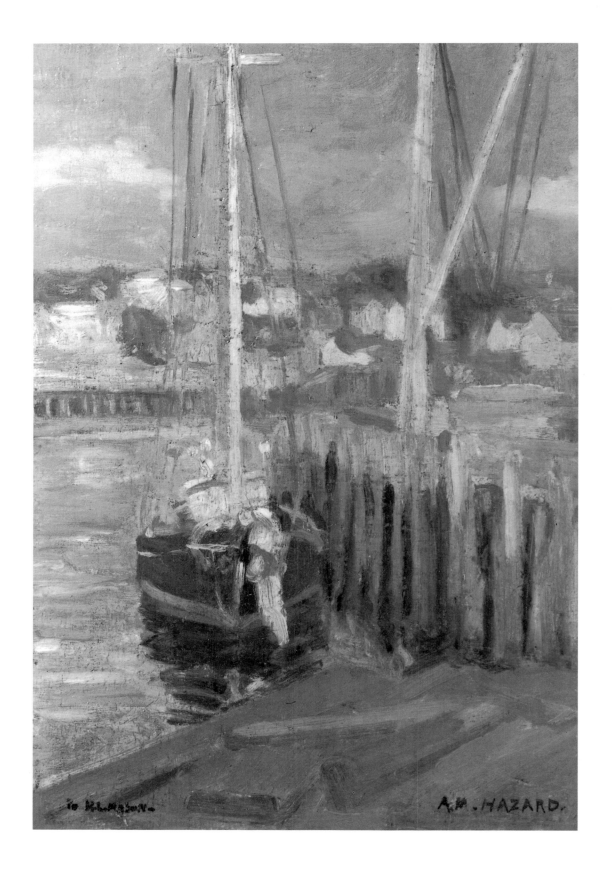

to H.L.Mason. A.M.HAZARD.

John Twachtman and the Artistic Colony in Gloucester at the Turn of the Century

by William H. Gerdts

A tradition of landscape painting that records the appearance of and activity in the town of Gloucester on Cape Ann dates back to 1840, when Gloucester-born Fitz Hugh Lane painted his earliest-known oil paintings, although he had created a lithograph *View of the Town of Gloucester, Massachusetts* in 1836. Beginning in 1844, when he painted his *Gloucester Harbor* from Rocky Neck, many of Lane's oils were devoted to rendering his native town, to which he returned from Boston to reside permanently in 1847. Lane in turn was the teacher of Mary B. Mellen during the 1850s, after she had moved to Gloucester with her husband, the Reverend C. W. Mellen, who became the Universalist minister there; both Mrs. Mellen and the much younger D. Jerome Elwell of Gloucester executed some works in the manner of Lane, although Elwell achieved a reputation based primarily on Venetian and Dutch views painted in a broader, more poetic, Barbizon-influenced manner.[1]

Gloucester thus harbored native and resident painters as early as the mid-nineteenth century, and many landscapists from New York and Boston painted views in and around the town in these and succeeding decades. From the 1850s through the seventies, Gloucester was visited by artists such as John F. Kensett, Francis Silva, Raymond Yelland, Alfred Bellows, Edward Moran, James Craig Nicoll, Stephen Salisbury Tuckerman, Kruseman Van Elten, and, most notably, Winslow Homer in the summer of 1873 and again in 1880. These were transient painters in the town, however; as yet Gloucester held no distinction or special attraction for the artistic community.

The earliest artists' colony to be formed in the Gloucester area centered around the tragically brief stay of William Morris Hunt, who in 1877 established a studio at nearby Magnolia, on the west side of Gloucester Bay; that summer he painted *Gloucester Harbor* (fig. 1) which in its sensitivity to the effects of light and atmosphere on the shoreline boats, buildings, and piers, established the *topos* for the majority of renditions of Gloucester for the next three decades. Although Impressionism had not yet made its appearance in America, Hunt's comment to his pupil Helen Knowlton that "I have painted a picture with *light* in it,"[2] prefigures the aesthetic concerns of many Gloucester painters of the next generation. Knowlton herself preceded Hunt, summering and painting there in 1876 with her colleague Lillian Freeman Clarke. Hunt's presence in Gloucester the following year attracted some of his other pupils (most of whom were female), such as Ellen Day Hale and Rose Lamb. Hunt

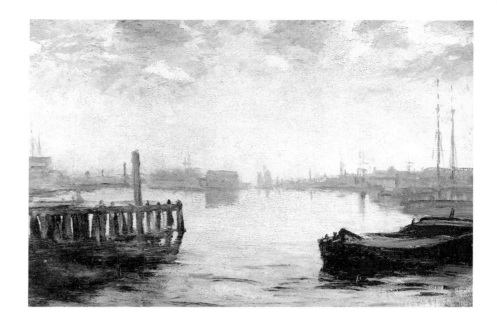

spent little time in Magnolia in 1878, as he was preoccupied with the murals for the New York State Capitol in Albany, and in 1879 he spent the summer on Appledore, one of the Isles of Shoals, where he died by drowning in early September. Knowlton stayed on in Magnolia, but the artists' colony had ceased to exist by 1884, when she moved to Dublin, New Hampshire.[3]

By that time, a new center for artistic expression had been established on the northwestern end of Cape Ann in the village of Annisquam, where William Lamb Picknell painted regularly during the summers of the eighties, after spending ten years studying and working abroad in Paris, Brittany, and England. An artists' colony grew up around Picknell and is said in 1889 to have numbered thirty artists; the most notable of these were the brothers Hugh Bolton Jones and Francis Coates Jones, who joined with Picknell in the exhibition *Pictures at Annisquam* at the Williams & Everett's Gallery in Boston in December 1886.[4]

Knowlton continued her interest in the Gloucester area even after leaving Magnolia, and in 1890, in an article she wrote for the *Studio* entitled "A Home-Colony of Artists," she noted the tremendous artistic activity that was taking place on the North Shore of Massachusetts in general, and on Cape Ann in particular.[5] Knowlton recorded that, in addition to the presence of Picknell and the Jones brothers, the Boston painter Joseph DeCamp was teaching a class of more than twenty young Philadelphia women at Annisquam, while "East Gloucester was never so full of artists, and was getting to be called the Brittany of America." She observed that the English-born watercolorist Rhoda Holmes Nicholls was there with her husband, painter Burr Nicholls from

Buffalo, and that she was teaching a class of a dozen pupils who came to her from New York, the South, and as far away as Texas. Frank Duveneck from Cincinnati held a class in oil painting for a group of students from Boston; they executed beach scenes, harbor-scapes, views of wrecked vessels, and occasionally worked out-of-doors from the model. In her article, Knowlton also commented upon the advent of Impressionism in the painting and teaching at Gloucester through the influence of Theodore Wendel. He had previously worked in Giverny, France, in the shadow of Claude Monet, and had subsequently become identified with Newport, Rhode Island; in the summer of 1890 he took charge of Duveneck's class for a week, " studying deeply into the mysteries of light upon color. . . . Pure color, fresh from the tube. . . ."

Gloucester would seem to have been particularly conducive to the expression of Impressionist light and color. Willard Metcalf, who had been associated with Wendel at Giverny in the late 1880s, summered in Gloucester in 1895; at this time he painted his first American landscapes since he had left the country in 1883 to study abroad, and he began, under the influence of Childe Hassam, to work in a colorful divisionist technique. This constituted Metcalf's earliest investigation of Impressionist light and color, and when six of his Gloucester landscapes were exhibited the following year at the Society of American Artists' annual exhibition in New York City, his *Gloucester Harbor* was awarded the Webb Prize for the finest landscape in the exhibition.[6] Hassam himself was painting watercolors in Gloucester as early as the summer of 1890, stopping there on his way either to or back from Appledore, where he was part of the coterie that assembled around the writer Celia Thaxter—which Hunt had been part of earlier. Hassam was back in Gloucester in the summer of 1894, just before Thaxter's death, and the *Gloucester Daily Times* noted that he was residing at the Delphine, a cottage at the Hawthorne Inn in East Gloucester, and that he was showing "some delectable works to those privileged to enter his little cottage."[7] He was there again in the summer of 1895, along with Metcalf. The paintings from Hassam's stay in Gloucester, or technically East Gloucester, were rendered in the colorful and broken-brushwork Impressionist manner with which he had returned from three years in France, in the autumn of 1889, and which established him as one of the premier artists of that avant-garde movement. In subject matter, his work was quite varied and included both close-up views of the town and sweeping panoramas of the harbor, as well as pictures of old houses, dock laborers and the like. He was back again in 1899, painting expansive harbor views not dissimilar from some painted by John Twachtman, one of his colleagues in the newly formed Ten American Painters group, who summered in Gloucester the following year.

Thus, by the turn of the century, Gloucester and its environs was a magnet for painters to sojourn in the summer not only from Boston but also well beyond. If few artists resided there—one notable exception was the self-taught Gloucester fisherman-turned-painter George Wainwright Harvey, who

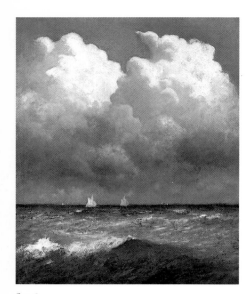

fig. 2
Reginald Coxe, *Seascape*. Oil on canvas.
Private collection

emerged in the late 1870s—Gloucester also sparked the creativity of painters who were working on scenes done either on the spot or from sketches developed in their studios in the winter months. Broadly speaking, the artists of the time fell into three groups. There were those like Hassam and Metcalf who went to Gloucester for single or occasional visits; there were those who were regulars, reported to spend at least part of every summer painting on Cape Ann; and there were those even more closely identified with Gloucester, who had permanent studios and whose principal works were the products of long summer and even autumnal residences ended only when the severe weather made it impractical to remain.

Reginald Cleveland Coxe was one of the principal summer-resident painters. Though born in Baltimore and trained in Paris under Léon Bonnat, he was primarily identified with Buffalo; when in early 1893 he left to take a studio in New York City, the Buffalo newspapers noted the move as a distinct loss to the city, but he was back as President of the Buffalo Society of Artists by the end of the century."[8] However, in 1890, he had not only joined the Gloucester art colony, but he had also taken a well-situated home there. Knowlton reported that "[Coxe is] the most envied of all the artists here. He has taken a ten years' lease of a fine 'colonial'-looking farm house, which is the centre of the most charming combination of scenery that we have ever chanced to see in any country. Behind the house is Gloucester Harbor, in front a little gem of a pond, on which lie the white water lilies and a boat, old and picturesque. . . . Beyond this fresh pond one sees the ocean with its wild rocks and dashing surf. To the south of the farm-house is an apple-orchard, as paintable as an Italian olive grove. In all our wanderings we have yet to find a spot more individual, more attractive to an artist of poetic temperament" (see fig. 2).[9]

Coxe may have been lured to Gloucester that summer of 1890 in part by the presence there of his fellow Buffalonian, Burr Nicholls. He certainly utilized his position in Gloucester to become a well-regarded specialist in marine paintings, some of which included figures engaged in various activities. Coxe wrote poignantly about his life in Gloucester during the summers and autumns in an article that appeared in *Century* in August 1892, and he illustrated it with etchings of the sailing ships in the harbor. In the essay, he concentrated upon the rugged beauties of the land and weather and the lives of the fishermen who were his companions and subjects, and he omitted any reference to the companionship of fellow artists. Another article, written by Theodore Purdy in 1895, described Coxe's absorption with marine painting and featured an illustration by him depicting a vigorous struggle of sailors and fishermen against the power of the ocean.[10]

Augustus W. Buhler and Walter Lofthouse Dean were two other part-time residents of Cape Ann; both had permanent studios there. Buhler began summering at Annisquam as early as 1885 but interrupted his annual visits to study abroad in 1888; on his return from Europe in 1890, he again made his winter home in Boston and summered at Annisquam. By 1898, he had moved

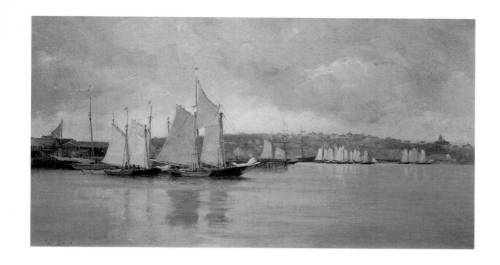

to Rocky Neck in East Gloucester, where he not only painted the active lives of the fishermen but also engaged in teaching. Walter Dean was a close colleague of Buhler, known as "the painter of the New England fishing population" (see fig. 3).[11] Like Coxe, both Buhler and Dean remained on Cape Ann well into the autumn. Buhler explained that: "Cape Ann and especially Gloucester and its harbor are favorite places for artists in the summer months, but during that season of the year, the business of fishing is at its ebb, so that these enthusiasts do not see the fishermen . . . in the full rush of fall business. Then is the time to catch them at their best, coming in and going out of the harbor, in their various kinds of fishing crafts. . . ."[12]

One wonders about the possible interaction between the early Annisquam artists' group centered around Picknell and the Jones brothers, and Buhler, whose early years in 'Squam overlapped with the group's activity there. In an August 1903 article in the *Boston Sunday Globe*, Annisquam was criticized as having become too much of a tourist attraction, which had caused it to be deserted by many of its former artist-visitors, although the writer noted that there was still a number of regulars who kept studios there—today rather little known painters such as Henry Hammond Gallison, Melbourne H. Hardwick, and Edward Parker Hayden. By 1903, Coxe appears to have vacated, at least temporarily, his admired Gloucester studio, for in addition to Buhler and Dean, the only other resident summer artists that year were Theodore Victor Carl Vallenkampf, a specialist in the painting of square-riggers, and Eugenie M. Heller. Heller, who was then enjoying her eleventh season in Gloucester, painted in both oil and watercolor and was also known for her woodcarving.[13]

The same writer noted too that Edmund E. Case of Springfield, Massachusetts, had been summering on Cape Ann for several years. He was certainly there in 1900, along with Twachtman and a large number of other summer artist-visitors, for he was listed as a participant in the exhibition held at the

Rockaway Hotel in East Gloucester by the artists staying there, as reported in the *Gloucester Daily Times* on 10 August: "During the season such prominent artists as [Frank] Duveneck, [Joseph] DeCamp, [Alfred Vance] Churchill, [Arthur Merton] Hazard, [Dana] Pond, [Edward] Potthast, [Charles L.] Adams, [Edmund E.] Case, [John] Twachtman, [Charles] Corwin, A[lbert] C. Fauley, L[ucy] S. Fauley, Katherine T. Farrell, Walter Clark and his son Eliot Clark, have arrived at the Rockaway, and in their coming the art of Massachusetts, Chicago, New York, Philadelphia, and the West have united in happy congeniality and the universal love of Gloucester and its never-ending charms for the artist. . . . Mr. Walter Dean joined the exhibitors and sent several of his fine marines to add to this charming exhibit."[14]

Though it is certain that by 1900 Gloucester and its neighbors (East Gloucester was actually the preferred summer residence for the majority of the painters who went to the Cape by 1900, replacing Annisquam in popularity) constituted a major summer artists' colony, it may be that that year was a particularly fruitful one, both in the numbers of artists who painted there that summer, and in the renown of so many of them, though further investigation may prove that the immediately succeeding years in particular were as illustrious, and that exhibitions of the artists' summer work continued to be held locally. What drew the seemingly diverse group together that summer, not only to East Gloucester but to the Hotel Rockaway, is not totally clear, but certainly the nucleus of the representation drew from two interrelated factors—the majority of the artists were from the Midwest, especially Ohio, and the best-known of them, in addition to Duveneck, had been Duveneck's pupils in Munich. Thus, the communal activity, resulting in the summer exhibition, constituted something of a double reunion of Ohio, particularly Cincinnati, artists, and of Munich-trained painters, some of whom began their out-of-doors painting working with Duveneck at Polling in Bavaria in the summers of 1877 and 1878 and later in Venice. And, as the writer for the August *Gloucester Daily Times* article noted, Pond was in turn a pupil of DeCamp and thus constituted a third generation in the Duveneck and Munich heritage.

The present exhibition centers upon the work that Twachtman produced during summers spent in Gloucester from 1900 to 1902, and this essay focuses, more specifically, on the paintings executed by both Twachtman and several of his fellow artists in 1900. There are various indications but, as yet, no clear proof that Twachtman may have at least visited Gloucester earlier; certainly its general popularity among the artists of the period, and perhaps especially among the painters with whom he was associated would make such a previous visit very probable. Twachtman, after all, was a member of the predominantly Impressionist-oriented Ten American Painters, along with Hassam, Metcalf, and DeCamp, all three of whom had worked in Gloucester before 1900. And we have noted that among his Munich confreres, both DeCamp and Duveneck had taught classes in Gloucester as early as 1890. In addition, his fellow Cincinnatian Edward Potthast had begun summering in Gloucester in 1896,

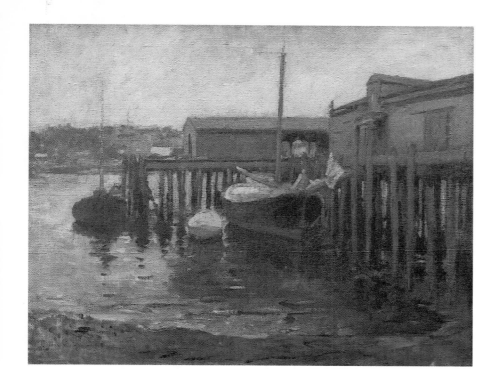

the same year he left his native city and settled in New York, and he continued to do so for many of the following twenty-five summers.

Nevertheless, Twachtman's commitment to Gloucester and the subsequent change in his aesthetic strategies, which has been characterized as something of a return to the vigorous handling, stronger tonal contrasts and reintroduction of blacks in his palette—qualities that are identified with the Munich manner of painting practiced by some of the Americans working there in the 1870s—may well be due to the regrouping of Duveneck and his "Boys." As noted earlier, Duveneck had been in Gloucester as early as 1890; he was there again 1892 and 1893, but he began to summer regularly beginning in 1899, and continued to do so until his death in 1919. On the other hand, if the presence of Duveneck and some of his other Munich companions directed Twachtman toward more dramatic effects in his rendering of the appearance of Gloucester, its boats, wharves, and harbor, Twachtman's full if personal commitment to Impressionism may account for the more brilliant coloration and greater sensitivity to effects of light that Duveneck's Gloucester landscapes assumed. Duveneck even maintained two separate studios by different parts of Gloucester harbor, to better study the atmospheric effects of both morning and afternoon light.[15] At times, too, his paintings adopted the densely worked, small brushstrokes of the Impressionist aesthetic and an increasingly high-keyed palette, though it seems probable that the most colorful of these harbor scenes were painted considerably later, after Twachtman's death in

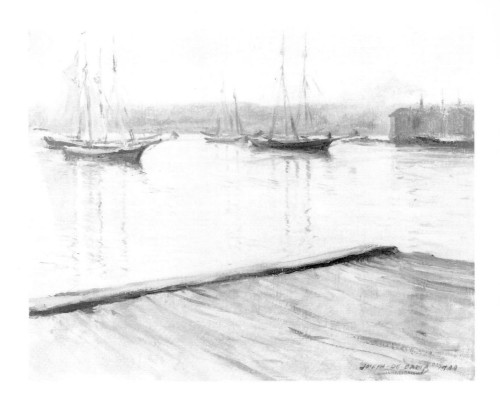

Gloucester in 1902. Duveneck's *Gloucester Pier* of about 1900 (fig. 4) is more low-keyed, more traditional in this regard. There were critics and fellow painters, of course, who considered Duveneck's later, Gloucester work as something of a betrayal of the creativity manifested in his early, Munich years, which had inspired so many followers. Vallenkampf described Duveneck's career to the young James Britton in Gloucester, and in concluding remarked, "He used to paint beautiful things, but they say his work now is poor."[16]

DeCamp's *Gloucester* (fig. 5) shares both the expressive brushwork and oblique angularity of composition found in many of Twachtman's Gloucester paintings done at the same time, and it is not dissimilar either from Duveneck's *Gloucester Pier*. Appropriately, DeCamp gave the canvas to Duveneck, his former teacher, who donated it to the Cincinnati Art Museum in 1915. The two artists had enjoyed a long association: DeCamp studied with Duveneck in Munich and Polling in 1878 and accompanied him to Florence and Venice the following year. DeCamp, in fact, may have been the first of the group of artists who showed their work at the Rockaway Hotel in 1900 to have worked on Cape Ann; he painted landscapes at Annisquam in 1886 and may have then joined the group centering around William Picknell.[17] By that time DeCamp had established himself as a major teacher in Boston and, as we have seen, he led a class of young women from that city to study in Annisquam in 1890. Primarily a figure and portrait painter, his known landscapes are relatively few and most

of them make only hesitant concessions to the Impressionist aesthetic. Also a member of the Ten American Painters, his earliest paintings shown in the group's annual exhibitions must have appeared to be among the most conservative. DeCamp's solid craftsmanship assured him high regard as a teacher in various Boston art schools—that of the Museum of Fine Arts, the Cowles School, and the Normal Art School. Young Dana Pond was only nineteen when he joined his teacher, DeCamp, in Gloucester that summer of 1900.

Like Twachtman and DeCamp, Edward Potthast was both Cincinnati-born and Munich-trained, but he studied in the Bavarian capital from 1882 to 1885, long after Duveneck and his "Boys" had left. Meanwhile, Potthast returned to Europe in the late eighties and became the first artist in Cincinnati to adopt the strategies of Impressionism. His Gloucester scenes have been ignored, however, while the emphasis has been placed on his New York beach subjects.[18] Unfortunately—at least for art historians!—Potthast, like a good many other artists working in Gloucester during the period discussed in this essay, tended to sign but not to date his work, so it is extremely difficult to come to conclusions concerning his chronology. More specifically, there is no way of determining which of his Gloucester harbor scenes might have resulted from the summer spent painting with Duveneck, Twachtman, and DeCamp, and which were shown in the Rockaway Hotel exhibition. Many of the pictures by Potthast that are identified as Gloucester scenes are similar in subject to works by Twachtman and the others, but they are less loosely painted and often

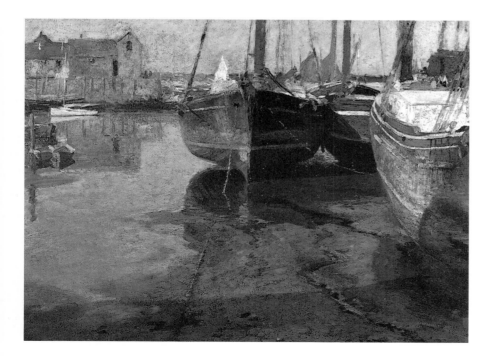

fig. 6
Edward Potthast, *Gloucester*. Oil on canvas, 41 × 51 in. Collection of Sewell C. Biggs

CORWIN'S·PRIZE·PICTURE

fig. 7
Charles Abel Corwin, *Ten Pound Island*.
Whereabouts unknown

concentrate on the strongly modeled sailing vessels and their reflections in the water below (see fig. 6). Some, too, depict nocturnal subjects, which his colleagues seem to have avoided.

Though not from Cincinnati, Charles Abel Corwin was the other Munich-trained painter and member of the Duveneck coterie, having studied with him in that German city and also at Polling around 1878, at the same time as DeCamp. In 1891, Corwin settled in Chicago, and he had become an instructor at the evening school of the Art Institute of Chicago by 1900. His Gloucester paintings are unlocated today, however he exhibited a group of them in a one-man show at the galleries of Charles E. Cobb on Boylston Street in Boston.[19] More significant, though, is that of all the artists painting in Gloucester in the summer of 1900, it was probably Corwin who gained the most notoriety for his work of that period. Later that year, Corwin submitted five of his Gloucester paintings to the *Thirteenth Annual Exhibition of Oil Paintings and Sculpture by American Artists*, which opened in October at the Art Institute of Chicago. Corwin's *Ten Pound Island* (fig. 7) was awarded the newly instituted Martin Cahn Prize of $100, and the picture was purchased by Martin Ryerson, one of Chicago's leading art patrons and collectors. The critics commended Corwin for the group of harbor and shipping scenes, and they attributed his advance over his previous work to the stimulus of a new environment. The canvas was praised for its Whistlerian qualities, for being "simply composed, musical in

fig. 8
Alfred Vance Churchill, *Untitled (Rockport Harbor I)*, 1905. Oil on canvas, 18 × 22 in. Collection of the Smith College Museum of Art, Northampton, Massachusetts, Gift of Mrs. Kimball Valentine (Beatrice Gale '25)

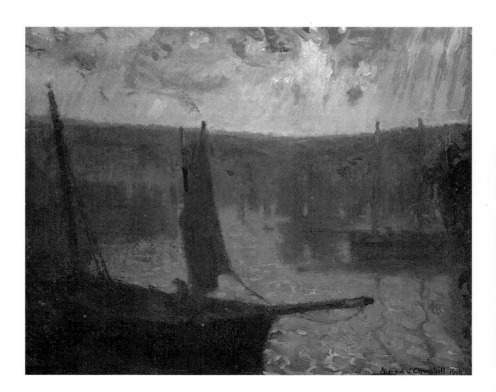

tone, filled with soft atmosphere."[20] However, an uproar followed among the artists of Chicago who felt that finer works by more talented and more progressive painters had been overlooked, and they threatened "an immediate exodus of Chicago's best painters to the East."[21] It was not antipathy to Corwin or disdain for his Gloucester paintings that angered the art community, but rather the obtuseness of the jury of awards. Needless to say, the community ultimately remained intact.

The other painters who showed their work at the Rockaway Hotel exhibition are today less well known, some such as Charles L. Adams, extremely so. Edmund Elisha Case was one of the leading landscape painters of Springfield, Massachusetts; although his Springfield landscapes were widely appreciated, none of his Gloucester works have yet surfaced. However, he exhibited a Cape Ann scene in the 1895 annual exhibition at Gill's Art Galleries in Springfield, and he was a friend and colleague of both Picknell and DeCamp, which suggests the possibility of a connection with Annisquam as early as the mid-1880s.

Alfred Vance Churchill is best known as having been a teacher at Smith College in Northampton, Massachusetts, a position he assumed only in 1906. Like so many of the exhibitors in Gloucester in 1900, he, too, was Ohio born and had taught in the Midwest before moving to Northampton, first at Iowa College and then at Teacher's College in Columbia, Missouri, from 1897 to 1905, the period during which he summered in Gloucester. As a painter, he was a landscapist; he worked in a Barbizon mode and later continued painting in this style in Barbizon and in the Forest of Fontainbleau as well as in Moret and Paris (see fig. 8). Arthur Merton Hazard may have chosen to summer and paint in Gloucester because of the presence of his teacher, DeCamp, with whom he had studied in Boston (see fig. 9). Landscape painting would not become a significant aspect of his art, however, and he became known primarily for his portraits and his allegorical works related to World War I. His most ambitious achievement was a fifty-two-foot-wide mural decoration for Temple Adath Israel on Commonwealth Avenue in Boston containing three thousand figures symbolizing the Jewish faith.[22]

Like so many of the artists in Gloucester in 1900, Albert Fauley and his wife, Lucy Stanbery Fauley, were from Ohio. They were among the leading painters of Columbus, where Albert was also the instructor at the Columbus Art School. Both were active landscape painters, and judging by their exhibitions with the Columbus Art League and elsewhere in the capital city over many decades, they continued to summer and paint in Gloucester. Even as late as 1917, when the Fauleys were living in Granville, Ohio, just east of Columbus, an exhibition of their work was held in Cleveland Hall in that town; the show featured over a hundred of their paintings, a substantial number of which were created in Gloucester. Moreso than his wife's, Albert's works concentrated upon harbor and dock scenes and especially on the salt barks and other ships (see fig. 10).[23]

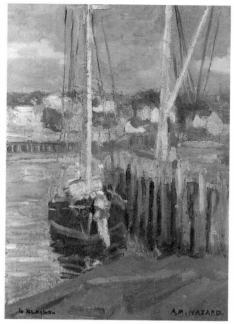

fig. 9
Arthur Merton Hazard, *Gloucester Scene*. Oil on canvas, 14 × 10 in. Collection of Alexander Raydon, Raydon Gallery, New York

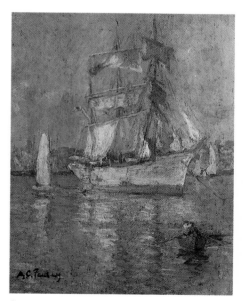

fig. 10
Albert C. Fauley, *Sail Boat*, c. 1905. Oil on canvas, 20 × 16 in. Collection of the Columbus Museum of Art, Columbus, Ohio, Gift of Hervey Whitaker

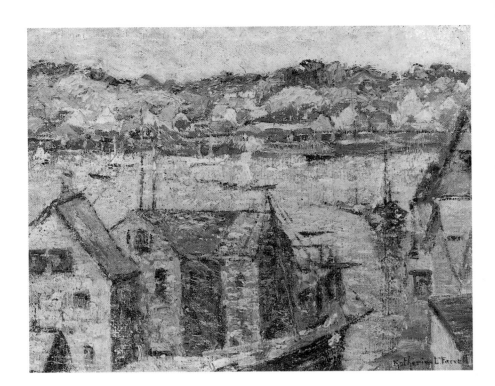

fig. 11
Katherine Levin Farrell, *Gloucester Harbor*,
c. 1910. Oil on canvas board, 10 × 12 in.
Collection of the Lagakos-Turak Gallery,
Philadelphia

In addition to Lucy Fauley, the other woman painter included in the 1900 exhibition in Gloucester was Katherine Levin Farrell, a once well known landscape and marine artist who summered regularly in East Gloucester.[24] During the rest of the year, she lived and painted in her native Philadelphia. She had studied there, and though she ceased painting for a while after her marriage to Theo P. Farrell in 1888, she resumed her lessons in Gloucester with Buhler, the leading teacher in the area, and this undoubtedly accounted for her annual seasons on Cape Ann. Farrell's located paintings are extremely colorful and vigorously executed landscapes and views of Gloucester harbor, but as with the works of so many of the artists dealt with in this essay, they are undated (see fig. 11).

With Walter and Eliot Clark we come to the end of the roster of participants in the Rockaway Hotel show. They were father and son, both landscape specialists, who, again, seem to have sojourned frequently in Gloucester. Walter Clark was one of the oldest of the exhibitors, born in 1848, the same year as Duveneck. His son, Eliot, was the youngest, only seventeen. Spurred on by his father, the precocious Eliot Clark exhibited with the New York Water Color Club at the age of nine and after studying with Twachtman for two brief months in the Antique class at the Art Students League of New York, he exhibited his first landscape at the National Academy of Design in 1899. Eliot's father, however, discouraged his formal study, confirmed in his belief that a

landscape painter trained better by working directly from nature. Walter Clark's painting is primarily Barbizon- and Tonalist-oriented, but his works of the 1890s indicate that he was beginning to explore more adventuresome, colorist effects, undoubtedly under the influence of some of his colleagues, such as Twachtman, and this transition from Tonalism to Impressionism can be found in the work of his son also.[25] Gloucester canvases by both the Clarks are known, though there are none that can be specifically documented to 1900. Eliot Clark's *Under the Wharf, Gloucester* (fig. 12), undated, is typical both of their known work and of the paintings by all the artists exhibiting in the 1900 show at the Rockaway Hotel.

Eliot Clark was later President of the National Academy of Design, about which he wrote a most valuable history. Indeed, he was a significant writer on American art; he published books and articles on American Tonalists and Impressionists, but the artist about whom he wrote most often was John Twachtman. Writing on the Rockaway Hotel exhibition, the reviewer for the *Gloucester Daily Times* noted that Twachtman had shown a "group of very small pictures which he termed 'postage stamps' [and which] were marked $100 each. Mr. Twachtman is a modern impressionist."[26] Katherine Metcalf Roof, known principally as the biographer of William Merritt Chase, wrote about these or very similar works, which were on exhibition in New York at the American Art Galleries in the spring of 1903, shortly after the artist's death in Gloucester on 8 August of the previous year. She observed that

> among the pictures in this last collection [at the American Art Galleries] were a number of small impressions painted upon panels made from the lids of cigar-boxes which he had himself prepared for the purpose. These were all East Gloucester subjects, and though seldom representing more than an hour's work, were among the most notable things in the exhibition. Although small in size, they had the value of large canvases and had unusual distinction in both composition and treatment. They were quiet patches of Gloucester harbor, with delightfully placed "spots" of trees and roof-tops; weather-stained groups of fish-sheds and wharves; the tall, sun-bleached piles, sea-greened at the base, with their moving reflections in the water; the coming, going, or waiting ships, perhaps with spread sails drying in the sun after a storm. Works strictly correct and thoroughly pleasing.[27]

The memory of these "postage stamps" was sufficiently strong that Eliot Clark recalled it years later, in 1924, writing about the summer he and his father spent in Gloucester with Twachtman and their other colleagues: "I well recall an incident in Gloucester. Several artists were stopping together at one of the Summer hotels. Twachtman had been painting rather large canvases (that is, about twenty-five by thirty, for pictures were not painted as large at that time as at present). He took great joy in joking the others about painting on small canvases. One couldn't paint a picture on them; why not work on a real

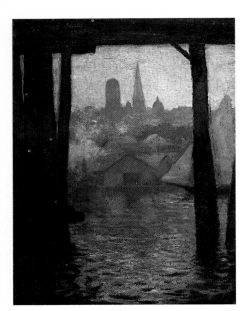

canvas, and so forth. Within a fortnight's time he was painting small thumb-box panels, using cigar-box covers which he treasured with great care."[28]

Clark also recalled the tremendous appeal that Gloucester held for Twachtman. "Harbours and shipping seem always to have held a vague fascination for the painter who enjoyed the pictorial suggestiveness of houses, wharves, water, and their infinite possibilities for artistic arrangement. The hills of East Gloucester, looking down on the harbour, likewise give the painter splendid themes for spotting, spacing and that variety of form which is so necessary to design."[29] It is obvious, too, that during the 1920s Clark was reconsidering his estimation of the work of Twachtman's last creative period. In 1921, he wrote in an article that "in some of the canvases we feel the lack of sustained effort, the consistent building up of pictorial purpose, and a too great reliance upon the mood of the moment. In consequence the result is uneven, the brush at times is too uncontrolled, evading the form too freely. In experimenting with the unity of form and colour and their effective relations, the painter has neglected their content and significance otherwise."[30]

In the book he wrote about Twachtman and his art three years later, Clark had better resolved his reactions to the Gloucester paintings. He repeated some of his previous comments, noting in these canvases "a joy in the first attack." He determined that the unevenness he found in these works was due to the fact that

> many of the Gloucester pictures are, in fact, unfinished canvases which were started in a moment of interest and then discontinued. But the best examples attain great beauty of design and individual expression. Among these, perhaps the most interesting are the motives looking down on the harbor from the hills of East Gloucester, where the fish houses and wharves jutting into the water and the distant city form an effective background for the rocky pastures and patterned trees of the nearer plane. Each picture seems to a certain extent an experiment, a venturing into new realms of consciousness and appreciation, and it is precisely this quickened spirit that the painter has so successfully imparted to the spectator.[31]

Clark was referring here to paintings such as the beautiful *Gloucester Harbor* in the collection of the Canajoharie Library and Art Gallery (pl. 5). In this and other works, the tremendous sensibility and emotional appeal which we sense as Twachtman's personal reaction to a setting he enjoyed so much is indeed very striking. Yet today we are equally impressed by his new coloristic sensibility, which combines almost pastel-like tones of greens, yellows, blues, and lavenders with stronger and more vigorous chromatic contrasts, and is heightened by the reintroduction of rich blacks. The dynamics of his newly expanded palette work in tandem with plunging perspective lines which, though often arranged on contrasting diagonals, at the same time affirm a compositional structure based upon a solid geometric grid. These elements

derive convincingly from the reality of Gloucester—its docks and sheds, as in *Waterfront Scene, Gloucester* (pl. 2); its landings and piers, as in *Little Giant* (pl. 7); the structure of the fishermen's homes, as in *Gloucester, Fishermen's Houses* (pl. 18); in the forms of the fishing boats and their repeated masts, as in *Fishing Boats at Gloucester* and *Bark and Schooner* (pls. 1, 12). The geometric underpinning of these expansive and colorful scenes is also especially evident in his last unfinished work, *Harbor View Hotel* (pl. 19).

Many of the strategies which Twachtman successfully explored in these paintings characterize as well the work of his companions who were in Gloucester in the summer of 1900. Gloucester was a fishing town, not a resort, but Twachtman and his associates present it in a colorful and dashing manner, attractive and appealing to the viewer. For all their expressiveness of the reality of a port, these pictures are genteel, as, indeed, was the sense of camaraderie among them that summer. This bond was certainly enhanced by the presence of teachers such as Duveneck and DeCamp and by the relationships that developed between them, their pupils, and others—the Fauleys, husband and wife, and the Clarks, father and son. In the work of all these artists what is perhaps especially strange is the almost total absence of figures or figural activity. Twachtman, it is true, was exclusively a landscape painter; he depicted the figure extremely rarely, and he never displayed true mastery of the subject . The same was true of the Clarks and some of the other artists residing at the Rockaway that summer. And even though many of them—Duveneck, DeCamp, and Potthast, for example—had had extensive

fig. 13
Augustus W. Buhler, *Hauling the Trawl*, 1902. Oil on canvas. Whereabouts unknown

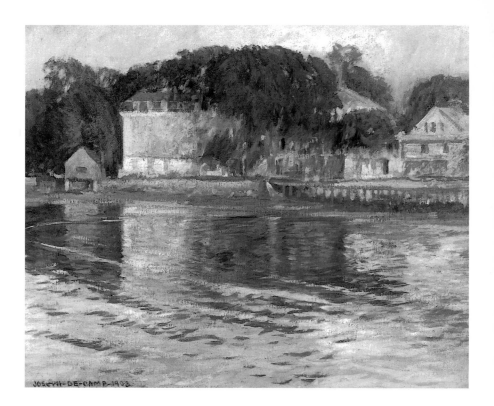

fig. 14
Joseph DeCamp, *The Little Hotel*, 1903. Oil on canvas, 20 × 24¼ in. Collection of the Pennsylvania Academy of the Fine Arts, Philadelphia, Temple Fund Purchase

experience in figure painting, it was all but completely avoided by the summer painters on the whole.

Hassam had painted figural works earlier in Gloucester, but by and large it was left to the regular and more permanent resident artists to probe the daily lives of the people of Gloucester—the men involved in shipbuilding and especially the fishermen. The latter was a theme undertaken as far back in art history as the 1840s by Fitz Hugh Lane. Picknell painted both fishermen and coastal scenes at Annisquam in the 1880s as did Coxe during the following decade. Above all, it was Gloucester's own Buhler who sailed with the fishing fleet and who devoted his art to portraying the lives and appearances of the men he knew so well, in works such as *Hauling the Trawl* (fig. 13), painted in 1902, the same year that marked Twachtman's last summer in Gloucester.

Such a theme, however, was not the mandate that Twachtman and his associates assumed during the first three summers of this century. In keeping with the mood of much landscape painting of the time, primarily Impressionist in aesthetic, their art was lively, colorful, luminous, and occasionally joyous. For Twachtman, this period was also a short conclusion to an extremely meaningful career. His associations during the summers of 1901 and 1902 are less well defined. In 1955, DeCamp's widow recalled evenings when her husband sat around and talked with Duveneck, Twachtman, and Wendel.[32]

Wendel was closely connected to this group, one of the "Duveneck Boys" from the Munich years, and then living in nearby Ipswich. He, too, had been in Gloucester early in the summer of 1900, though this was more likely a visit with his friends and former associates than an extended stay, and Mrs. DeCamp's reminiscences suggest a gathering at the Hawthorne Inn and therefore more probably a recollection of a later year.

Childe Hassam was in Gloucester, briefly at least, in mid-September of 1900, visiting with his colleagues, and a single Gloucester painting by him dated to 1902 is known, though there is no further record of his stay there that summer. Frederick Oakes Sylvester, the leading landscape painter of St. Louis, appears to have visited Gloucester in the summer of 1901, for the St. Louis *Mirror* noted that Sylvester's *Gloucester, Mass.*, shown with the Society of Western Artists in 1902, was the artist's "most ambitious picture," and that it "gives a group of piles rising out of the water of the fore portions of the composition, with boat-houses beyond. There is a strong effect of morning light, and the play of color reflected from the sky by the dancing water is represented with excellent effect. It is a vigorous piece of painting—luminous and sparkling."[33] The description indicates that Sylvester, too, had adopted the artistic strategies explored by Twachtman, Duveneck, and the others, and one might well presume that professional interaction took place between them and others during Twachtman's last two summers in Gloucester.

And, of course, Duveneck, DeCamp, and many of the painters who showed in the 1900 group exhibition at the Hotel Rockaway continued to summer in Gloucester after Twachtman died. Another of DeCamp's now rare landscapes is *The Little Hotel* (fig. 14), painted in the summer of 1903, the year following Twachtman's death. In it, DeCamp has shown a shallow cove at flood time, seen from the lawn of the house he had rented that summer at Rocky Neck in Gloucester; the building depicted may be the Hawthorne Inn, where the artists had previously gathered on occasion. The work documents De-Camp's increasing exploration of Impressionist aesthetics, his move away from the more tonal strategies of his earlier *Gloucester* of 1900 (fig. 5), the picture which he had given to his former mentor, Duveneck. It represented an artistic direction and development which Twachtman himself had earlier taken, and it was a painting he almost certainly would have admired.

Footnotes

1. There are two standard studies of the art of Gloucester. The first is a publication of The Gloucester 350th Anniversary Celebration, Inc., *Portrait of a Place: Some American Landscape Painters in Gloucester*, essay by John Wilmerding (Gloucester, 1973), which also functioned as an exhibition catalogue, with that section written by James F. O'Gorman. Wilmerding's essay, "Interpretations of Place: Views of Gloucester, Massachusetts, by American Artists," had previously appeared in *Essex Institute Historical Collections* 103 (January 1967): 53-66. The second is O'Gorman, *This Other Gloucester: Occasional Papers on the Arts of Cape Ann, Massachusetts* (Boston: the author, 1976). Twachtman is discussed on pp. 66-69. See also Harrison Cady, "Cape Ann, America's Oldest Art Colony," *American Artist* 16 (May 1952): 36-38, 62-63. The most comprehensive study of Lane is John Wilmerding, *Fitz Hugh Lane* (New York: Praeger Publishers, 1971).

2. Helen M. Knowlton, *Art-Life of William Morris Hunt* (Boston: Little Brown & Co., 1899), p. 119.

3. Essex Institute, *William Morris Hunt and the Summer Art Colony at Magnolia, Massachusetts, 1876-1879*, exh. cat., essay by Frederic A. Sharf and John H. Wight (Salem, Mass., 1981). See also the articles of the early 1880s in the local publication *Magnolia Leaves*, some of which were written by Helen Knowlton.

4. Picknell's Annisquam work is discussed and catalogued in Christine E. Bergman, "William Lamb Picknell" (Honors project, Institute of Fine Arts, New York University, Spring 1980). See also Edward Waldo Emerson, "American Landscape-Painter: William L. Picknell," *Century Magazine* 62 (September 1901): 710-713; and Avery Art Galleries, *Criticisms about Picknell* (New York, 1890). For the show of Annisquam pictures, see Williams & Everett's Gallery, *Pictures at Annisquam by W. L. Picknell, H. Bolton Jones and Francis C. Jones; also Two Portraits by J. H. Caliga*, exh. cat. (Boston, [1886]). The reference to an artists' colony of thirty painters, all veterans of Pont-Aven Brittany, is taken from the Dayton Art Institute, *American Expatriate Painters of the Late Nineteenth Century*, exh. cat., essay by Michael Quick (Dayton, Ohio, 1976), p. 27, but no source for this information is given.

5. Helen M. Knowlton, "A Home-Colony of Artists," *Studio* 5 (14 July 1890): 326-327.

6. Elizabeth de Veer has, as always, been most generous with her definitive knowledge of the art and career of Willard Metcalf.

7. I am grateful to Kathleen Burnside, who is working on the catalogue raisonné of Hassam's work, for information and material on the artist's visits to Gloucester. Hassam's return to the Delphine, a cottage at the Hawthorne Inn, was noted in the *Gloucester Daily Times*, 2 July 1894.

8. Material on Coxe is exceedingly scarce; my information derives from the Hauenstein scrapbooks of art and artists' clippings at the Albright-Knox Art Gallery, Buffalo, New York. I would like to thank Helen Raye, Assistant Curator of Paintings there for sending me this material. See also Theodore Purdy, "The Wildness of the Waves," *Monthly Illustrator for the Third Quarter of 1895* 5 (1895): 183-186.

9. Knowlton, "*A Home Colony of Artists*," p. 327.

10. Reginald Cleveland Coxe, "In Gloucester Harbor," *Century Magazine* 44 (August 1892): 518-522; and Purdy, "The Wildness of the Waves."

11. For Buhler, see the monograph by Joyce Butler, *The Artist As Historian: Augustus W. Buhler 1853-1920* (Gloucester: Cape Ann Historical Association, 1983. Dean regularly exhibited large numbers of Gloucester paintings in such shows as *Exhibition of Paint and Clay Club in Gallery of Williams & Everett's*, Boston, 1900.

12. Quoted in Butler, *The Artist as Historian*, from "Painting Under Difficulties," *Boston Globe*, 8 January 1901.

13. "Artists' Summer Homes in Gloucester and Annisquam," *Boston Sunday Globe*, 30 August 1903, p. 44.

14. *Gloucester Daily Times*, 10 August 1900, p. 6. I am tremendously grateful to Lisa Peters for locating this article, around which this essay has been constructed.

15. The literature on Duveneck is fairly extensive, but almost all of it ignores his work in Gloucester. This period in his career first received serious recognition in the exhibition *Frank Duveneck* held in 1972 at Chappellier Galleries, New York (catalogue essay by Francis W. Bilodeau). See also Fine Arts Museums of San Francisco, *Talent of the Brush: Fourteen Paintings by Frank Duveneck*, exh. cat., essay by Elizabeth Boone (San Francisco, 1986).

16. *Art Review International* 1, no. 10-20 (1920): 60-61.

17. The relatively meager literature on DeCamp, consisting of articles and tributes, deals almost exclusively with his portraits and figure paintings. For his landscapes in general, and his experiences on the Cape, see the material compiled and deposited by Donald Moffat with the Archives of American Art,

Smithsonian Institution, Washington, D.C., which includes a partial listing of his known paintings, located, unlocated, and destroyed.

[18] The best studies of Potthast are the two essays by Arlene Jacobowitz: "Edward Henry Potthast," *Brooklyn Museum Annual* 9 (1967-68): 113-128; and that in Chapellier Galleries, *Edward Henry Potthast 1857-1927*, exh. cat. (New York, 1969).

[19] *Group of Paintings by Charles Abel Corwin in the Galleries of Charles E. Cobb, 346 Boylston Street*, Boston, n.d.

[20] See the columns in the *Chicago Post*, 3 November 1897; *Chicago Inter-Ocean*, 31 October 1900; and *Chicago Times-Herald*, 4 November 1900.

[21] "Artists Differ with Judges," *Chicago Tribune*, 31 October 1900.

[22] There are occasional periodical articles and exhibition catalogues concerning paintings by Churchill, Hazard, and other less well known artists. For biographical material, see Peter Hastings Falk, *Who Was Who in American Art* (Madison, Conn.: Sound View Press, 1985); and the earlier Arthur Nicholas Hosking, *The Artists Yearbook* (Chicago: Art League Publishing Associates, 1905), which is especially useful for artists of the period covered by this essay.

[23] There is much information on the Fauleys in the articles on art and the exhibitions of the Columbus Art League in the *Columbus Dispatch* and other local newspapers. I would like to thank the library of the Columbus Museum of Art for providing me with this material.

[24] For material on women artists such as Katherine Farrell and Lucy Fauley, see the exemplary work by Chris Petteys, *Dictionary of Women Artists* (Boston: G. K. Hall, 1985).

[25] On Eliot Clark and his art, see the two exhibition catalogues: University of Virginia Art Museum *Eliot Clark, N.A.*, essay by David Lawall (Charlottesville, Va., 1975), and Hammer Galleries, *Eliot Clark, American Impressionist 1883-1980*, exh. cat., essay by Richard H. Love (Chicago, 1980).

[26] *Gloucester Daily Times*, 10 August 1900, p. 6.

[27] Katherine Metcalf Roof, "The Work of John H. Twachtman," *Brush and Pencil* 12 (July 1903): 243.

[28] Eliot Clark, *John H. Twachtman* (New York: Privately Published, 1924), pp. 10-11.

[29] Clark, *Twachtman*, pp. 51-52.

[30] Elliot [sic] Clark, "The Art of John Twachtman," *International Studio* 72 (January 1921): lxxxi.

[31] Clark, *Twachtman*, pp. 52-53.

[32] Letter from Donald Moffat, Brookline, Massachusetts, to Mrs. Loren Eiseley, Pennsylvania Academy of the Fine Arts, Philadelphia, 23 March 1955, Moffat Papers, Archives of American Art.

[33] Quoted in Betty Jean Crouther, "'The Artist Sings for Joy': Frederick Oakes Sylvester and Landscape Painting in St. Louis" (Ph.D. diss., University of Missouri-Columbia, 1985), p. 250.

Foreword to the Catalogue

The paintings featured in the catalogue date from the summers of 1900 to 1902, when Twachtman worked in Gloucester, Massachusetts. Their arrangement, although not strictly chronological, suggests the direction in which the artist was progressing during the last years of his career. Canvases such as *Fishing Boats at Gloucester* (pl. 1) and *Reflections* (pl. 3), placed at the beginning of the catalogue, are more carefully and tightly rendered than, for example, *Beach at Squam* (pl. 14), *Landscape with Boat* (pl. 15), and *Gloucester, Fishermen's Houses* (pl. 18), presented toward the end, which demonstrate the painterly vigor and almost expressonistic fervor of Twachtman's late style.

For the documentation included in catalogue entries, I have relied greatly upon John Douglass Hale's seminal Ph.D. dissertation of 1957, *The Life and Creative Development of John Henry Twachtman*. Hale's study provides biographical material on Twachtman, an important critical discussion of his career, and a catalogue of his located and unlocated works, the former listed in Catalogue A, the latter in the Catalogue. For each painting in this exhibition that is featured in Hale, references to his dissertation are given.

In general, the catalogue entries present the standard documentation on the paintings, although more complete information on them will appear in the publication of the catalogue raisonné of Twachtman's art, which is currently under preparation by Ira Spanierman Gallery. For a number of works, alternate titles have been provided when they are important to the identification of a work. There are many problems with the titling of Twachtman's paintings, as he did not keep records and quite a few of the works are known to have been shown, even during the artist's lifetime, under various titles. In cases where paintings' names were changed over the years, alternate titles identify probable original titles. In provenance listings, dealers, galleries, and auction sales are indicated by brackets.

Many of Twachtman's exhibitions are referred to in abbreviated form in the catalogue entries; these shows and their abbreviations are given below. Although this list does not include all of the artist's major exhibitions, those in which his most important Gloucester Period works appeared are featured.

Art Institute of Chicago, *Exhibition of the Works of John H. Twachtman*, 8-27 January 1901 [Chicago, 1901]

Durand-Ruel Galleries, New York, *Paintings and Pastels by John H. Twachtman*, March 1901 [Durand-Ruel Galleries, New York, 1901]

Cincinnati Art Museum, *Exhibition of Sixty Paintings by Mr. John H. Twachtman, formerly resident in Cincinnati*, 12 April–16 May 1901 [Cincinnati, 1901]

Knoedler Galleries, New York, *Memorial Exhibition of Pictures by John H. Twachtman*, January 1904 [Knoedler Galleries, New York, 1904]

Lotos Club, New York, *Exhibition of Paintings by the Late John H. Twachtman*, January 1907 [Lotos Club, New York, 1907]

New York School of Design for Women, *Exhibition of Fifty Paintings by the Late John H. Twachtman*, 15 January–15 February 1913 [School of Design for Women, New York, 1913]

Buffalo Fine Arts Academy, Albright Art Gallery, *Exhibition of Paintings and Pastels by the Late John H. Twachtman*, 11 March–2 April 1913 [Buffalo, 1913]

Munson-Williams-Proctor Institute, Utica, New York, *Presenting the Work of John H. Twachtman*, 5–28 November 1939 [Utica, 1939]

Babcock Galleries, New York, *Paintings, Water Colors, Pastels by John H. Twachtman* 9–28 February 1942 [Babcock Galleries, New York, 1942]

Century Association, New York, *Exhibition of Paintings by Abbott Thayer and John H. Twachtman*, 5 March–4 May 1952 [Century Association, New York, 1952]

Cincinnati Art Museum, *A Retrospective Exhibition: John Henry Twachtman*, 7 October–20 November 1966 [Cincinnati, 1966]

Ira Spanierman Gallery, New York, *John Henry Twachtman, 1853-1902, an Exhibition of Paintings and Pastels*, 3-24 February 1968 [Ira Spanierman Gallery, New York, 1968]

The three 1901 shows are of particular importance to the present exhibition as they included many paintings, that Twachtman had recently executed in Gloucester. Unfortunately, the only records of the March exhibition at the Durand-Ruel Galleries in New York are newspaper reviews, since no catalogue existed. As the present Twachtman exhibition was being prepared, information about a large show of his work held in January 1901 at the Art Institute of Chicago came to light. The show's catalogue and Chicago newspaper reviews are made use of for the first time in this publication. The presentation, which included forty-nine works, was important enough to bring Twachtman to Chicago for the opening. The artist arrived on 7 January and stayed for eight days; during his visit he delivered a series of lectures to art

students in which he urged the Institute to end its neglect of local artists. Visitors to the 1901 Chicago exhibition were rewarded with the opportunity to compare Twachtman's art with that of the French Impressionists Edouard Manet, Claude Monet, Camille Pissarro, and Alfred Sisley, whose paintings were featured in a small loan exhibition located in a room just beyond the galleries in which Twachtman's work was hung. One reviewer pointed out the difference between Twachtman's "rough paint strokes held gloriously in hand" and those "of his great predecessors, Claude Monet and Sisley, whose paintings occupy the small room beyond" and whose "collections of daubs 'carry' wonderfully." Many of the paintings on view in Chicago were also included in the April 1901 presentation at the Cincinnati Art Museum, *Exhibition of Sixty Paintings by John H. Twachtman, formerly resident in Cincinnati*, although eleven additional works were shown in Cincinnati. *Twachtman in Gloucester: His Last Years, 1900-1902*, brings together the largest number of Twachtman's last works to be exhibited since 1901.

L.N.P.

Plate 1

Fishing Boats at Gloucester

Oil on canvas
25⅛ × 30¼ in. (63.7 × 76.7 cm.)
Signed lower right: *J. H. Twachtman*
Collection of the National Museum of
American Art, Smithsonian Institution,
Washington, D.C., Gift of William T. Evans

In Gloucester, Twachtman turned from the lyrical and evanescent landscapes he had painted during his years in Greenwich, Connecticut, to create scenes of heightened visual intensity. The artist stood on a Gloucester dock to paint this view of fishing boats and wharves and directly expressed the inspiration he received from the subject. Rendering diagonal lines that plunge backward and forward into space, he set out a composition of great breadth. His brushwork activates the foreground boats, whereas behind, outlines of sheds dissolve and resolve themselves in shifting patterns. Twachtman's sure paint handling, "amounting to almost a shorthand of suggestion," reveals the revival of the dark palette of his Munich years, while the light colors "are still the luminous ones that the artist had learned from years of painting the snows on Round Hill Road [in Greenwich], whites unyellowed by any use of Munich's varnish," as John Douglass Hale wrote.[1] Although not painting with the bright colors he used for other Gloucester works, Twachtman enlivens his subject by forcefully stroking dry pigment across the canvas. Unlike the French Impressionists, who explored optical phenomena, Twachtman, in his Gloucester Period, conveyed the excitement of perception. The "increased personal force" noted by a *New York Tribune* critic in 1901 is immediately apparent in this painting.[2]

HALE: cat. A p. 542, no. 67; illus. p. 245, fig. 46; discussed pp. 162, 243, 247, 264-265.

PROVENANCE: Martha Twachtman (the artist's wife), Greenwich, Connecticut; through [Silas Dustin, New York] to William T. Evans, Montclair, New Jersey, 1906; to present coll., 1909.

EXHIBITIONS: National Gallery of Art (now National Museum of American Art), Washington, D.C., *Exhibition on the Occasion of the Opening of the Gallery in the New Building of the United States National Museum*, March 1910, cat. no. 86; Utica, 1939, cat. no. 6; Cincinnati, 1966, cat. no. 87; IBM Gallery, New York, *Portrait of America: 1865-1915*, 16 January-25 February 1967, cat. no. 24.

REFERENCES: William H. Holmes, *Catalogue of Collections I: Smithsonian Institution, The National Gallery of Art* (Washington, D.C.: Washington Government Printing Office, 1922), p. 47, no. 124; ———, *Catalogue of Collections II: Smithsonian Institution, The National Gallery of Art*, rev. ed. (Washington, D.C.: Washington Government Printing Office, 1926), p. 58, no. 124; Allen Tucker, *John H. Twachtman* (New York: Whitney Museum of American Art, 1931), pp. 46-47, illus; "The American Impressionists," *Time*, 26 March 1956, p. 86, illus.; William H. Truettner, "William T. Evans, Collector of American Paintings," *American Art Journal* 3 (Fall 1971): 60, illus. fig. 10; Richard Boyle, *John Twachtman* (New York: Watson-Guptill Publications, 1979), pp. 80-81, illus. pl. 30; *Descriptive Catalogue of Painting and Sculpture in the National Museum of American Art* (Boston: G.K. Hall & Co., 1983), p. 196; William Kloss, *Treasures from the National Museum of American Art* (Washington, D.C.: Smithsonian Institution Press, 1985), pp. 216-217, illus.

[1] John Douglass Hale, *Life and Creative Development of John H. Twachtman*, 2 vols. (Ann Arbor: University Microfilms, 1958), Ph.D. dissertation, Ohio State University, 1957, pp. 264-265.
[2] "John H. Twachtman," *New York Tribune*, 9 August 1902, p. 3.

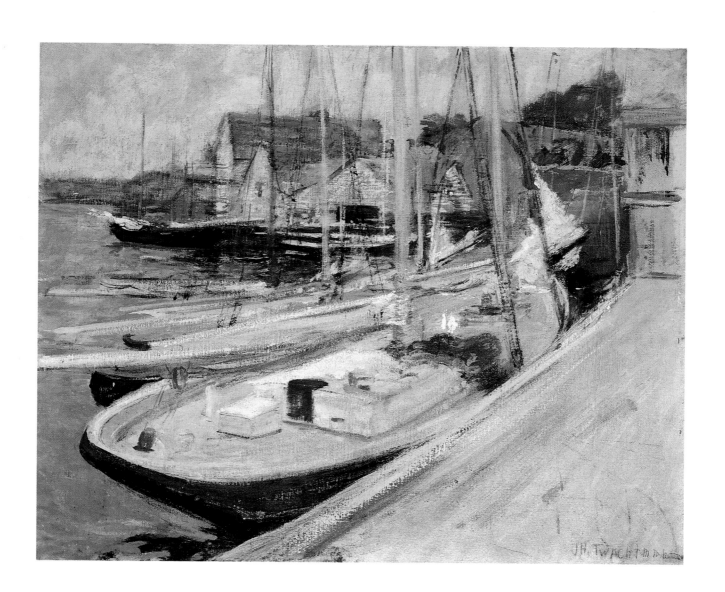

Plate 2

Waterfront Scene—Gloucester

Oil on canvas
16 × 22 in. (40.6 × 55.8 cm.)
Signed lower left: *J. H. Twachtman*
Collection of Mr. and Mrs. Raymond J.
 Horowitz

In comparison with the quiet, sedate landscapes that many of his contemporaries painted at the turn of the century, Twachtman's scenes of Gloucester are emotional—in some cases, fevered—transcriptions of his subjects. The atmosphere in *Waterfront Scene—Gloucester* is tense—full of powerful clashes of color and form. Layering pigment forcefully onto the canvas, the artist creates a lively and energetic surface. He accentuates the irregular lines of sheds along a wharf with strokes of green and blue over shades of lavender and red. The landscape seems very noisy, yet at the same time still and empty. The mood of this work perhaps suggests Twachtman's sensitivity to conflicts that were emerging with the onrush of the twentieth century.

HALE: cat. A p. 577, no. 688; illus. p. 392, fig. 142.

PROVENANCE: Son of W. A. Putnam; Mr. and Mrs. Allen T. Clark; [Ira Spanierman Gallery, New York, 1966]; to present coll., 1966.

EXHIBITIONS: Ira Spanierman Gallery, New York, 1968, cat no. 23, illus.; Metropolitan Museum of Art, New York, *Summer Loan Exhibition: Paintings, Drawings and Sculpture from Private Collections*, 1966, cat. no. 188; ———, *American Impressionist and Realist Paintings and Drawings from the Collection of Mr. & Mrs. Raymond J. Horowitz*, 19 April-3 June 1973, cat. no. 21, illus.

REFERENCES: Hilton Kramer, "American Paintings in 'The Picnic Spirit,'" *New York Times*, 29 April 1973, p. 21, illus.; William H. Gerdts, *American Impressionism* (New York: Abbeville, 1984), p. 190, illus. pl. 202.

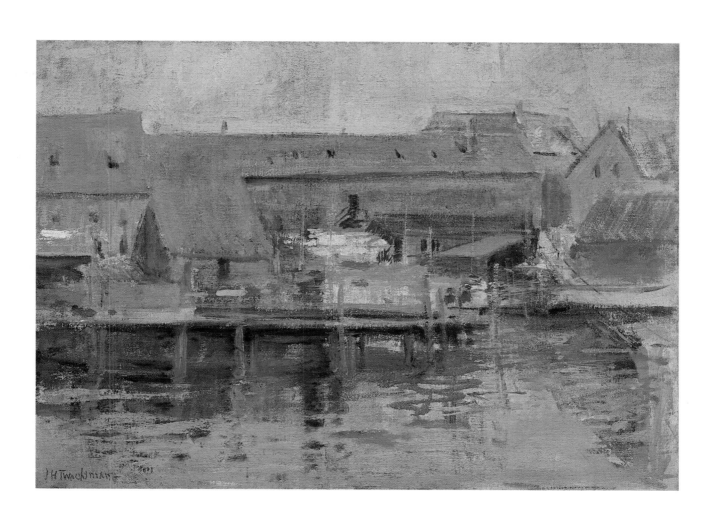

Plate 3

Reflections

Oil on canvas
30 × 30¼ in. (76.2 × 76.8 cm.)
Signed lower left: *J. H. Twachtman*—
Collection of the Brooklyn Museum,
New York, Dick S. Ramsay Fund

Eliot Clark wrote in 1921 that "Twachtman had a very happy faculty of arrangement without seeming effort, the effect of which was to heighten and strengthen the salient characteristics of the subject, and to give it a significance singular to itself."[1] In the landscape setting of *Reflections*, the presence of the zigzagging dock seems quite natural; however, Twachtman has also maximized its effect in the composition. It stops the eye at the sparkling reflections in the foreground, bends into the middle distance, and, finally, extends elegantly to shoreline hills. Twachtman uses the solid dock to balance the more amorphous elements of the scene: the shimmering water and the feathery forms of the trees, treated with Impressionist dabs. He expresses his own susceptibility to the poetry of nature and entices the viewer to feel overwhelmed by it as well. A critic singled out *Reflections* when it was shown in Chicago in 1901, noting that "the gems of [Twachtman's] assembled works are the landscapes . . . or frontages on water. . . . Two of these works, 'Reflecting' and 'Reflections,' both done on the water, are as entrancing in color as any Venice scene ever painted—if seen at the distance of across the room."[2]

HALE: cat. A pp. 565-566, no. 493; illus. p. 217, fig. 30; discussed p. 215.

PROVENANCE: Alexander Morten, as of 1913; [American Art Association, New York, May 10, 1916]; to J. Alden Weir; [Knoedler Galleries, New York, c. 1917-19]; Horatio S. Rubens, New York, as of 1937; present coll., 1944.

EXHIBITIONS: Chicago, 1901, cat. no. 20; School of Design for Women, New York, 1913, cat. no. 37 (lent by Alexander Morten, Esq.); Buffalo, 1913, cat. no. 28; Knoedler Galleries, New York, *Ninth Annual Summer Exhibition of Paintings by American Artists*, 1916, cat. no. 24; Cincinnati Art Museum, *Twenty-Fourth Annual Exhibition of Paintings by American Artists*, 26 May-31 July 1917, cat. no. 69; Brooklyn Museum, New York, *Leaders of American Impressionism*, 15 October-28 November 1937, cat. no. 64 (lent by Horatio S. Rubens); Babcock Galleries, New York, 1942, cat. no. 6; Brooklyn Museum, New York, *Revolution and Tradition*, 15 November 1951-6 January 1952, cat. no. 80.

REFERENCES: E.A.F., *Chicago Journal*, 12 January 1901, unpaginated newspaper clipping, Scrapbook 13, p. 112, Ryerson Library, Art Institute of Chicago; "Exhibitions of the Week," *Chicago Times Herald*, 30 December 1901, unpaginated newspaper clipping, Scrapbook 13, p. 99, Ryerson Library, Art Institute of Chicago; "Art Notes," *New York Times*, 25 March 1903, p. 5; *Brooklyn Museum: American Paintings* (New York: Brooklyn Museum, 1979), p. 115.

[1] Elliot [sic] Clark, "The Art of John Twachtman," *International Studio* 72 (January 1921): lxxvii.
[2] E.A.F., *Chicago Journal*, 12 January 1901, unpaginated newspaper clipping, Scrapbook 13, p. 112, Ryerson Library, Art Institute of Chicago.

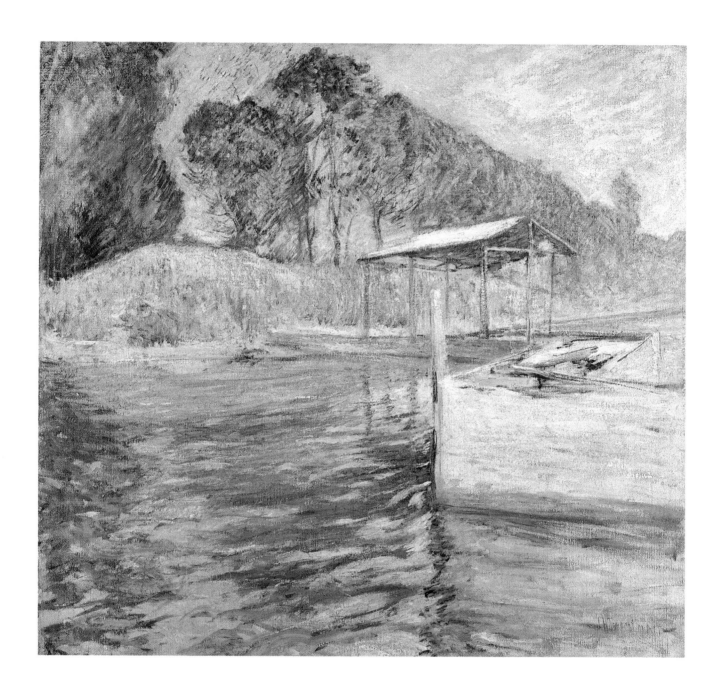

Plate 4

Gloucester Dock

Oil on canvas
5¾ × 10¾ in. (14.6 × 27.3 cm.)
Signed lower left: *J. H. Twachtman*
Collection of Mr. and Mrs. John T. Lupton

Twachtman chose a small barge as the subject for this work, endowing it with the elegance and strength of a larger vessel. His fresh color is laid on as if he had used pastels, which he worked in extensively in the 1890s. In addition, through gestural brushwork and calligraphic lines which delineate a crane on the wharf, Twachtman suggests the movement of forms and takes delight in their shapes. His interest in the crane and the barge anticipate the preoccupation with industrial subjects on the part of many twentieth-century artists.

PROVENANCE: Mrs. Frederick Schlesinger Dow, New York, until 1930; to her descendants; Private Collection; to [Ira Spanierman Gallery, New York]; to present coll., 1986.

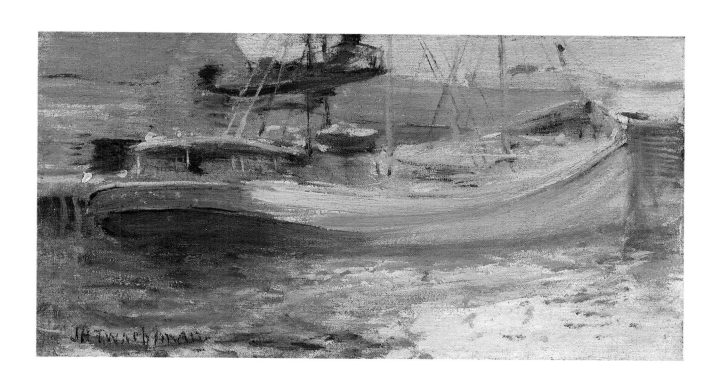

Plate 5

Gloucester Harbor

Oil on canvas
25 × 25 in. (63.5 × 63.5 cm.)
Signed lower right: *J. H. Twachtman*
Collection of the Canajoharie Library and
 Art Gallery, Canajoharie, New York

"The hills at East Gloucester, looking down on the harbour [gave Twachtman] splendid themes for spotting, spacing, and that variety of form which is necessary to design,"[1] as Eliot Clark noted. For *Gloucester Harbor*, Twachtman chose as his subject the profusion of gables, piers, and boats in the town, and the landscape of the distant shore. Yet on closer inspection, details also emerge—derricks along the water's edge, the spires of West Gloucester, and a ferry steaming past the East Gloucester pier. Twachtman guides our eye across the panoramic expanse, accentuated by the high horizon line, and at the same time invites us to inspect relationships of forms and various spatial sequences. The painting's unusual composition was taken notice of by a critic who in 1901 commented that the view "seen from above, is Japanese and charming in arrangement. We see the roofs of the houses and the slender landing stages running out into the water, like centipedes, on their many piles. . . ."[2] In this work and others, Twachtman does not impose a limiting artistic vision on the landscape; neither does he imply that the landscape is inherently orderly. Instead, he suggests that it is our powers of perception that allow us to organize and understand visual phenomena. Twachtman goes beyond the Impressionists' investigations of the retina to reveal the sense of order that the eye naturally seeks.

ALTERNATE TITLE: *The Ferry Landing*. It seems likely that this painting was shown as *The Ferry Landing* in Twachtman's 1901 exhibition at the Art Institute of Chicago: three reviews of the show include detailed descriptions of *The Ferry Landing*, and they correspond in every respect to the appearance of *Gloucester Harbor*. The painting may also have been exhibited at the Cincinnati Art Museum in the same year. Since the painting features the East Gloucester ferry landing, this title is suitable.

HALE: cat. A pp. 551-552, no. 243 as *Harbor Scene: Gloucester, Massachusetts*, and p. 551 no. 232 as *Gloucester Harbor*.

PROVENANCE: Mrs. Herbert Croly, New York; [Milch Gallery, New York]; J. K. Newman, New York; to [American Art Association, New York, *The J. K. Newman Collection of Important Paintings by American and French XIX-XX Century Artists*, 6 December 1935, cat. no. 26]; [W.H. Weidman]; [Parrish Watson]; [Macbeth Gallery, New York, 1938]; through Bartlett Arkell to present coll., 1939.

EXHIBITIONS: Cincinnati, 1901, cat. no. 47 (as *Ferry Landing*); Chicago, 1901, cat. no. 19 (as *The Ferry Landing*); Montclair Art Museum, New Jersey, *American Paintings by the Ten*, 1 January-10 February 1946, cat. no. 31; Century Association, New York, 1952; Cape Ann Historical Association, Gloucester, Massachusetts, *Portrait of a Place: Some American Landscape Painters in Gloucester*, 25 July-5 September 1973, cat. no. 13, illus.; Smithsonian Institution Traveling Exhibition Service, Washington, D.C., *Impressionnistes Américains*, traveling exhibition, April 1982-April 1983, cat. no. 74, illus.

REFERENCES: James O'Gorman, "Painting at Gloucester," *American Art Review* 1 (September-October 1973): 99, illus.

[1] Clark, "The Art of John Twachtman," pp. lxxx-lxxxi.
[2] "Exhibitions Next Week," *Chicago Post*, 5 January 1901, unpaginated newspaper clipping, Scrapbook 13, p. 103, Ryerson Library, Art Institute of Chicago.

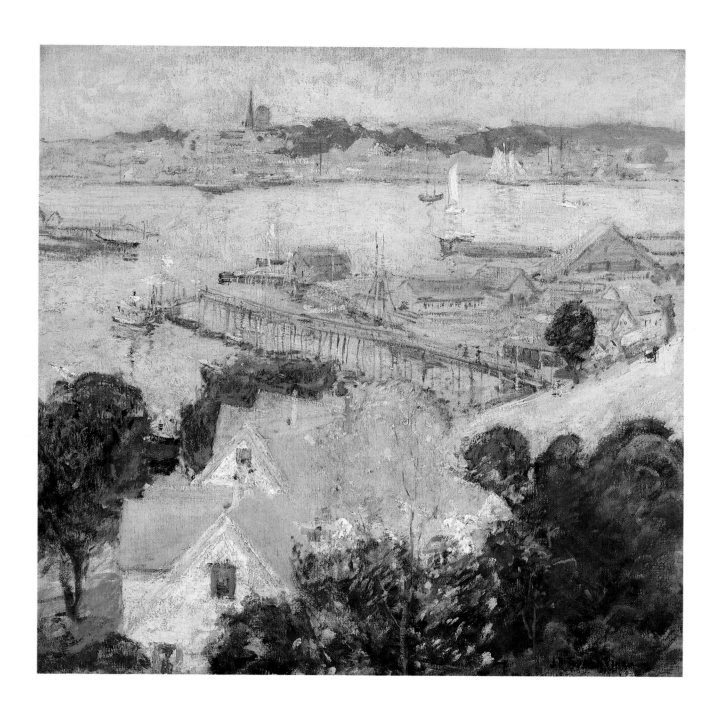

Plate 6

View from East Gloucester

Oil on board
12 × 9¼ in. (30.5 × 23.5 cm.)
Signed lower left: *J. H. Twachtman*
Collection of the Ira Spanierman Gallery,
New York

Painting with brisk and flowing strokes, Twachtman conveys effects of light and wind in this view looking past an East Gloucester dock and across Smith's Cove. His atmospheric treatment was observed by a critic who wrote in 1901 that "'A View from East Gloucester' is full of charm and the very breath of summer."[1] Although the painting was probably executed quickly, the composition is controlled through a strong arrangement of opposing triangles. In addition, by cutting diagonally across the work, the dock achieves a flattening effect as in a Japanese print and unifies the foreground and background.

ALTERNATE TITLE: *Ferry Landing*. There are two labels on the back of this work. One gives only the title *View from East Gloucester*, and it is therefore likely that this painting was shown in Twachtman's Chicago exhibition of 1901, which included a work of this title. It was probably also exhibited as *View of East Gloucester* in Cincinnati in the spring of that year. However, the other label on the back of the canvas indicates that on another occasion it was shown as *Ferry Landing*, probably at the *Pan-American Exposition* in Buffalo, since part of the name of the exposition is visible on the label. Twachtman's lack of concern with titles is especially evident as both this work and *Gloucester Harbor* (pl. 5) appear to have been exhibited under the alternate title *Ferry Landing*. But because this painting does not include a view of the landing, the title *Ferry Landing* seems incorrect in this case. Hale lists *View of East Gloucester* on p. 451, cat. no. 213.

PROVENANCE: Mitchel Work, until 1958; [Babcock Galleries, New York]; Robert Phillip; an unidentified educational institution in the eastern United States; to present coll., 1986.

EXHIBITIONS: Chicago, 1901, cat. no. 22 (as *View from East Gloucester*); Cincinnati, 1901, cat. no. 56 (as *View of East Gloucester*); New York State Building, Buffalo, New York, *Pan American Exposition*, 1901, cat. no. 779 (as *The Ferry Landing*).

REFERENCES: "Exhibitions of the Week," *Chicago Times Herald*, 30 December 1901, unpaginated newspaper clipping, Scrapbook 13, p. 98, Ryerson Library, Art Institute of Chicago.

[1] "Exhibitions of the Week," *Chicago Times Herald*, 30 December 1901, unpaginated newspaper clipping, Scrapbook 13, p. 98, Ryerson Library, Art Institute of Chicago.

Plate 7

Little Giant

Oil on canvas
20 × 24 in. (50.8 × 61 cm.)
Collection of the Ira Spanierman Gallery,
New York

The Little Giant was a steam tug that became a ferry in the late nineteenth century. Probably the most well known of the North Shore ferries, it carried residents and tourists throughout the day between Gloucester and East Gloucester. When it reached the Rocky Neck landing, depicted in Twachtman's painting, the ferry did not stop—passengers had to jump onto it. The artist captures the movement of the boat, rendering the roof of its open deck with a swath of quickly applied impastoed white. The figures aboard are treated sketchily and the ripples, echoing in their coloration the rose tint of the ferry, also indicate its motion. In contrast, Twachtman conveys the stillness of the hazy summer day; for example, on the distant shore, occasional sailboats blend with the softly contoured landscape. By incorporating areas of gray canvas prime and its rough weave into his tonal composition, Twachtman subtly enlivens the painting's surface. The striking yet delicate contrasts of color and form in *Little Giant* demonstrate the adventurousness and control he exercised simultaneously in his Gloucester Period works.

ALTERNATE TITLE: *Ferry at East Gloucester*. It is probable that this work was shown in exhibitions at the New York School of Design for Women and the Buffalo Fine Arts Academy in 1913 as *Ferry at East Gloucester*, lent in both cases by Twachtman's wife, who owned the painting at the time. The work has been identified as *Little Giant* since it entered the collection of Godfrey Twachtman (the artist's son), before 1957. Hale lists *Little Giant* in cat. A p. 550, no. 201, and *Ferry at East Gloucester*, p. 446, cat. no. 167.

PROVENANCE: Martha Twachtman (the artist's wife), Greenwich, Connecticut; Mr. and Mrs. Godfrey Twachtman (Godfrey Twachtman was the artist's son), Independence, Missouri; [Milch Gallery, New York]; Private Collection; [David Findlay Jr., Inc, New York, 1985]; to present coll., 1986.

EXHIBITIONS: School of Design for Women, New York, 1913, cat. no. 18 (as *Ferry at East Gloucester*, lent by Mrs. J. H. Twachtman); Buffalo, 1913, cat. no. 13 (as *Ferry at East Gloucester*, lent by Mrs. J. H. Twachtman); Cincinnati, 1966, cat. no. 89 (lent by Mr. and Mrs. Godfrey Twachtman); David Findlay Jr., Inc., New York, *On the Spot: American Painting 1865-1930*, October-December 1985, cat. no. 10, illus.

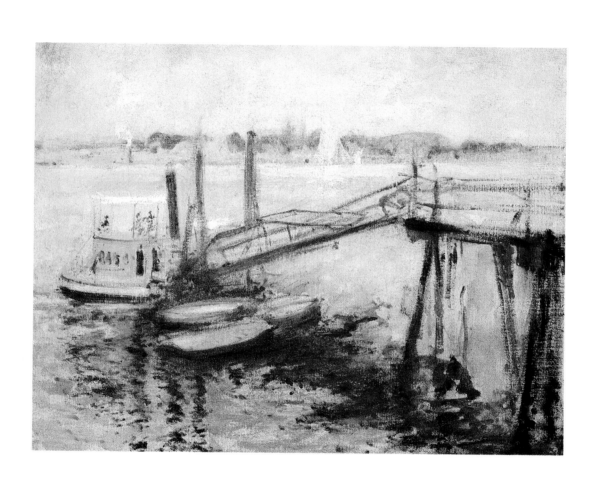

Plate 8

Boats in Harbor

Oil on paper board
9¼ × 9¼ in. (23.4 × 23.4 cm.)
Collection of the Hirschl & Adler
 Galleries, Inc., New York

Twachtman conveys the openness, stillness, and brilliant light sought by Stuart Davis and other artists who painted Gloucester later in the twentieth century in his canvas *Boats in Harbor*. Despite the scene's tranquility and the crisp and bright colors of the water and landscape, Twachtman allows dark shadows and strong vertical lines of masts and pilings to intrude. With an extreme economy of means, he expresses two contrasting moods of nature, juxtaposing the sparkle of a summer day with a foreboding tone, and in so doing perhaps mirrors his experience of life during his last years.

PROVENANCE: Mrs. Frederick Schlesinger Dow, New York, until 1930; to her descendants, until 1982; Private Collection; to present coll., 1985.

REFERENCES: *Antiques* 124 (September 1983): 402, illus.

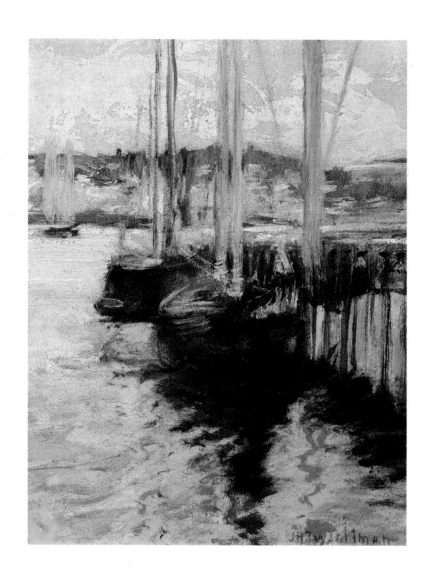

Plate 9

The End of the Rain

Oil wash on artist's board
11¾ × 12½ in. (29.8 × 31.8 cm.)
Signed lower left: *J. H. Twachtman*
Collection of the Brooklyn Museum,
New York, Gift of Allen Tucker

Gray days captivated Twachtman throughout his career. In 1892, he wrote J. Alden Weir from Greenwich, Connecticut, that "the weather continues very fine. There has been so much sunshine for months that a grey day is a fine and rare thing."[1] Gray and rainy days offered Twachtman opportunities to study the nuances of mood that occur with different atmospheric conditions. In Gloucester, he continued this pursuit.[2] In this work, he expresses the peaceful mood of the Gloucester landscape at the end of a rainy day by using sinuous lines to define forms, causing them to appear to shift and meld together. A critic reviewing Twachtman's 1901 exhibition in Chicago wrote that, "The entire east wall is occupied by a single line of, perhaps, seven pictures, all of them very pale and showing little contrast of parts. If studied closely, the forms resolve themselves into their suitable characters. . . . The genius was not nodding when he did them; not at all."[3] Another critic discussing the same exhibition commented that in many of the artist's views of East Gloucester "there seems to be some sort of a bay there round which the shore curves, and this circling movement is the main thing in several pictures."[4] Twachtman uses this motif in *The End of the Rain* to contrast the bold upward reach of the flamelike form of the tree in the right background with the other rounded and horizontally oriented elements of the landscape.

HALE: cat. A p. 565, no. 486b (it is assumed 486a is the same work); illus. p. 161, fig. 12; discussed pp. 160, 162.

PROVENANCE: [The American Art Galleries, New York, *Sale of the Work of the Late John H. Twachtman*, 19 March 1903, cat. no. 66]; to Allen Tucker; to present coll., 1923.

EXHIBITIONS: Chicago, 1901, cat. no. 32; Cincinnati, 1901, cat. no. 19.

[1] John H. Twachtman, Greenwich, Conn. to J. Alden Weir [location unknown], 26 September 1892, Library, Ira Spanierman Gallery.
[2] See Hale cat. nos. 217, 218, 228, 488a, 488b, 489, 952 for views of Gloucester in rainy and overcast weather.
[3] [Title of article and publication unknown], 1901, unpaginated newspaper clipping, Scrapbook 13, p. 116, Ryerson Library, Art Institute of Chicago.
[4] "Exhibitions Next Week," *Chicago Post*, 5 January 1901, unpaginated newspaper clipping, Scrapbook 13, p. 103, Ryerson Library, Art Institute of Chicago.

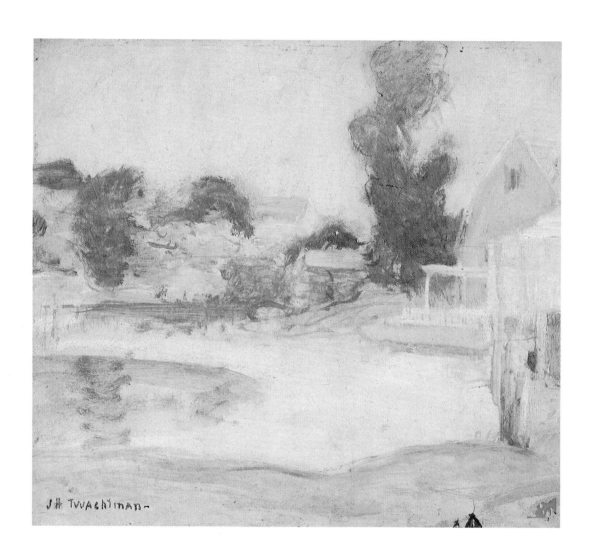

Plate 10

Gloucester

Oil on canvas
25 × 30 in. (63.5 × 76.2 cm)
Signed lower right: *J. H. Twachtman*
Collection of the Hirschl & Adler
 Galleries, Inc., New York

This depiction of Gloucester entices the viewer to approach the landscape, to pass from the gently sloping hills down to the u-shaped group of buildings below and to the open bay. The harmony of the arrangement was observed by a writer in an article in a 1925 issue of *Bulletin of the Art Institute of Chicago*: "[the painting] has that unity of mood, that invisibility of vision and expression which makes [Twachtman's] work unique. High and cool in color, thinly but firmly painted, the separate elements—shore, houses, water, sky—are clearly indicated but woven into a whole that is the very essence of the scene."[1] With this view of Gloucester, the artist suggests that we can find order in the landscape. He conveys the meditative experience that such settings offer and the solace they provide. As another author wrote, "The realistic . . . approach of Twachtman's early work has disappeared in this scene of Gloucester for a more poetic and personal atttitude. He represents the view as bathed in a soft, delicate light which blurs contours and immaterializes solid forms into amorphous, drifting areas of color. . . . there is an evanescent and delicate charm in the very lightness of the tonality."[2]

HALE: cat. A pp. 550-551, no. 204; illus. p. 325, fig. 86.

PROVENANCE: Estate of the artist, 1902-18; [Silas Dustin, New York]; to [Young's Art Galleries, Chicago, 1918]; Paul Schulze, Chicago, until 1923; to Art Institute of Chicago, Walter H. Schulze Memorial Collection, 1924-86, gift of Mr. and Mrs. Paul Schulze; present coll., 1986.

EXHIBITIONS: Young's Art Galleries, Chicago, *Paintings by Eminent American Old Masters and by some of the Prominent Living American Artists from the Collection of Young's Art Galleries*, 1918, cat. no. 6, illus.; Art Institute of Chicago, *A Century of Progress: Exhibition of Paintings and Sculpture*, 1 June-1 November 1933, cat. no. 484.

REFERENCES: Eliot Clark, "John Henry Twachtman (1853-1902)," Art in America 7 (April 1919): 135, illus.; R.M.F., "The Walter H. Schulze Memorial Gallery of Paintings," *Bulletin of the Art Institute of Chicago* 19 (January 1925): 9, illus.; Art Institute of Chicago, *A Guide to the Paintings in the Permanent Collection* (Chicago: Art Institute of Chicago, 1932), p. 174, no. 24.916; ———, *The Walter H. Schulze Gallery of American Paintings* (Chicago: Art Institute of Chicago, 1943), pp. 32-33, illus.

[1] R.M.F., "The Walter H. Schulze Memorial Gallery of Paintings," *Bulletin of the Art Institute of Chicago* 19 (January 1925), p. 9.
[2] Art Institute of Chicago, *The Walter Schulze Gallery of American Paintings* (Chicago: Art Institute of Chicago, 1943), p. 33.

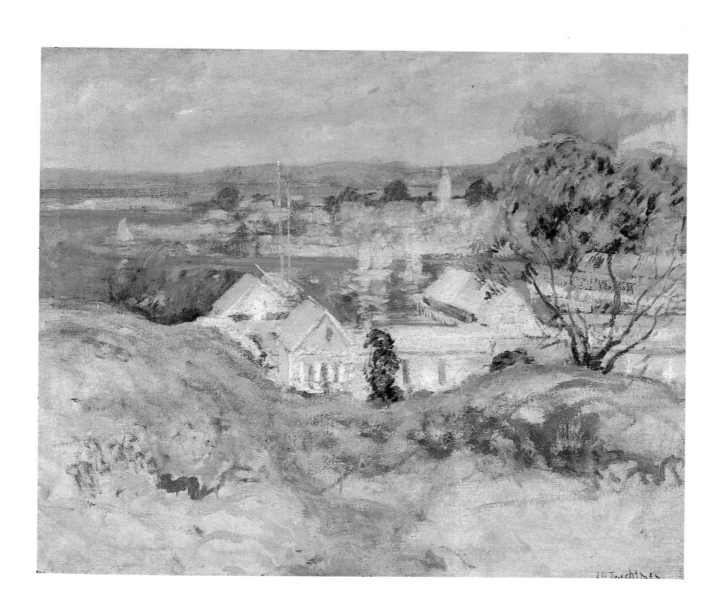

Plate 11

Wild Cherry Tree

Oil on canvas
30 × 30 in. (76.2 × 76.2 cm.)
Signed lower right: *J. H. Twachtman*
Collection of the Albright-Knox Art Gallery,
 Buffalo, New York

Twachtman painted *Wild Cherry Tree* from just to the left of his vantage point for *Gloucester* (pl. 10). However, the expansive harbor scene below is not the subject of this work. For *Wild Cherry Tree*, Twachtman allows the spreading branches of the cherry tree to partially intercede and block his view, and he takes his inspiration from the tree rather than from the site beyond it. As Hale noted, "we do not look through it . . . it is the subject of the painting."[1] In *Wild Cherry Tree*, the artist uses softly fanning branches and leaves to guide our eye without enforcing a particular focal point in the scene beyond. As was eloquently noted in a 1916 American Art Galleries catalogue: "The tree's slender, willowy branches distribute its feathery foliage almost wholly across the picture, emphasizing and relieving rather than obscuring the fair land- and sea-scape beyond."[2] In *Wild Cherry Tree*, Twachtman advances a concept he had explored earlier while staying at the Holley House in Cos Cob, Connecticut. In *Lilacs in Winter* (collection of the Toledo Museum, Ohio), he depicted a view of the neighborhood seen from the porch of the house through the lilac bushes. In the *Wild Cherry Tree*, branches and leaves seem to become one, and closeness and depth are compressed into a single experience. In 1907, a critic praised Twachtman's control of the subject, writing that, "Nothing is more difficult to reproduce than the aspect of country seen through interposing foliage. Twachtman rendered it here in the quality of a veil across the light."[3]

HALE: cat. A p. 574, no. 631; illus. p. 231, fig. 39; discussed pp. 228, 232.

PROVENANCE: Martha Twachtman (the artist's wife), Greenwich, Connecticut, as of 1903; Hugo Reisinger, New York; to [Plaza Hotel and American Art Galleries, New York, *Private Collection of the Late Hugo Reisinger*, 18-29 January 1916]; through [Knoedler Galleries, New York] to present coll., 1916.

EXHIBITIONS: Durand-Ruel Galleries, New York, *Sixth Exhibition: Ten American Painters*, 18 April-2 May 1902; Knoedler Galleries, New York, 1904, cat. no. 4; Pennsylvania Academy of the Fine Arts, Philadelphia, *102nd Annual Exhibition*, 1907, cat. no. 255; Museum of Modern Art, New York, *American Painting and Sculpture, 1862-1932*, 31 October 1932-31 January 1933, cat. no. 194; Brooklyn Museum, New York, *Leaders of American Impressionism*, 15 October-28 November 1937, cat. no. 61; Utica, 1939, cat. no. 4; Tate Gallery, London, *American Painting from the Eighteenth Century to the Present Day*, April-July 1946, cat. no. 213; Century Association, New York, 1952.

REFERENCES: *New York Daily Tribune*, 21 April 1902, p. 9; "Twachtman's Painted Poems," *New York Times*, 10 January 1905, p. 6; David Lloyd, "The Exhibition of the Pennsylvania Academy," *International Studio* 31 (March 1907): xx; Guy Pène du Bois, "A Few Auction Records for American Pictures," *Arts and Decoration* 6 (June 1916): 381, 383, illus.; Allen Tucker, *John H. Twachtman* (New York: Whitney Museum of American Art, 1931), pp. 34-35, illus.; Frank Jewett Mather, *The American Spirit in Art* (New Haven: Yale University Press, 1927), p. 126, illus.; "Utica: A Retrospective of Twachtman," *Art News* 38 (November 1939): 15-16.

[1] Hale, *Life and Creative Development*, p. 232.
[2] American Art Association, New York, unpaginated sale catalogue, 18-20 January 1916, cat. no. 28.
[3] David Lloyd, "The Exhibition of the Pennsylvania Academy," *International Studio* 31 (March 1907): xx.

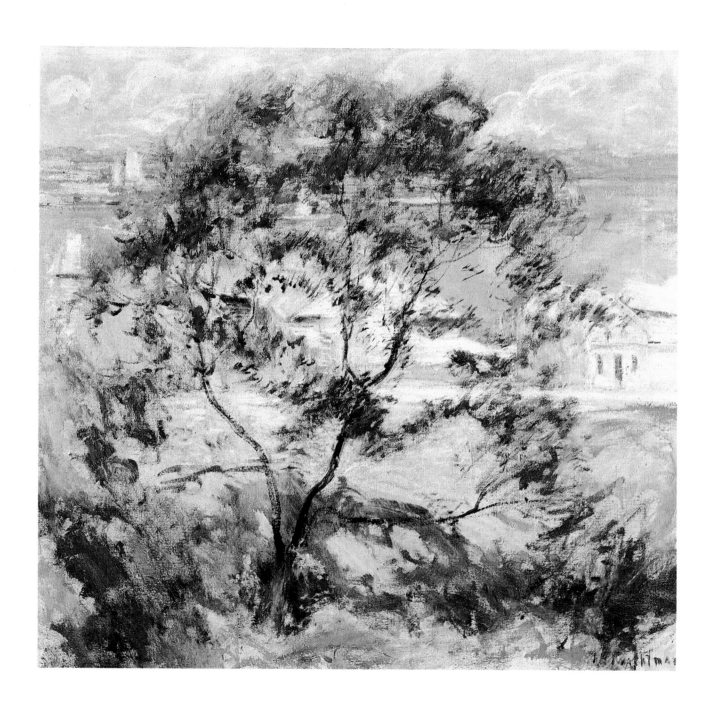

Plate 12

Bark and Schooner (Italian Salt Bark)

Oil on canvas
25 × 25 in. (63.5 × 63.5 cm.)
Signed lower right: *J. H. Twachtman*
Collection of the Sheldon Memorial Art
 Gallery, University of Nebraska, Lincoln,
 F. M. Hall Collection

Three-masted Italian ships, which brought salt for fish processing to local Gloucester schooners, were an exotic feature of Gloucester Harbor in the late nineteenth century. Twachtman makes no attempt to romanticize the subject in *Bark and Schooner (Italian Salt Bark)*. Instead of placing his bark within a traditional picturesque harbor scene, he depicts it from the side and positions it centrally on the canvas. This simple design is matched by the artist's execution. Working *à premier coup* and applying uninterrupted swaths of paint, Twachtman conveys the bark's shape as well as that of the small schooner in front of it. Water and reflections are handled with rapid touches to suggest the great depth of the ocean and to bring out the long shadows cast by the masts in late afternoon light. A critic may have been considering *Bark and Schooner* in 1901 when he or she wrote that, "Twachtman's canvases are never overworked . . . it is this very quality and strength of the brushwork that keeps them graceful and charming. . . . Every brushmark tells, his knowledge of drawing and technique enable him to paint rapidly and directly."[1]

HALE: cat. A p. 540, no. 38; discussed p. 268.

PROVENANCE: [Macbeth Gallery, New York]; [Ferragil Galleries, New York]; to present coll., 1931.

EXHIBITIONS: Chicago, 1901, cat. no. 17 (as *Italian Barque*); Nebraska Art Association, University of Nebraska Art Gallery, Lincoln, *41st Annual*, 12 February-15 March 1931, cat. no. 11; University of Iowa, Iowa Union, *Exhibition of American Paintings and Etchings Loaned by the University of Nebraska and the Nebraska Art Association*, 1940, cat. no. 21; Grinnell College, Iowa, *Paintings from the F. M. Hall Collection*, 1948, cat. no. 21; Cincinnati, 1966, cat. no. 90; Des Moines Art Center, Iowa, *The Kirsch Years: A Testimonial Exhibition*, 7 January-10 February 1974, cat. no. 71 (traveled to University of Nebraska Art Gallery, Lincoln 25 February-31 March 1974); Norfolk Arts Center, Nebraska, *Master Works of Twentieth Century American Painting*, 17 December 1978-26 January 1979, cat. no. 20, illus.; Henry Art Gallery, University of Washington, Seattle, *American Impressionism*, 3 January-2 March 1980 (traveled to Frederick S. Wight Gallery, University of California, Los Angeles, 9 March-4 May; Terra Museum of American Art, Evanston, Illinois, 16 May-22 June; Institute of Contemporary Art, Boston, 1 July-31 August); Smithsonian Institution Traveling Exhibition Service, Washington, D.C., *Impressionnistes Américains*, traveling exhibition, April 1982-April 1983; Madison Art Center, Wisconsin, *The Seasons: American Impressionist Painting*, 1984-85, cat. no. 51.

REFERENCES: *Art Collection Catalogue* (Lincoln: University of Nebraska Press, 1933), pp. 20, 27; "The Art Collections of the University of Nebraska," *Art Journal* 24 (Fall 1964): 44, illus. fig. 6; William H. Gerdts, *American Impressionism* (New York: Abbeville, 1984), p. 192, illus. pl. 215.

[1] *Columbus Ohio Journal*, 27 January 1901, unpaginated newspaper clipping, Scrapbook 13, p. 126, Ryerson Library, Art Institute of Chicago, written in anticipation of a show of Twachtman's works coming to Columbus, following its close at the Art Institute of Chicago, where *Bark and Schooner* was exhibited as *Italian Barque*.

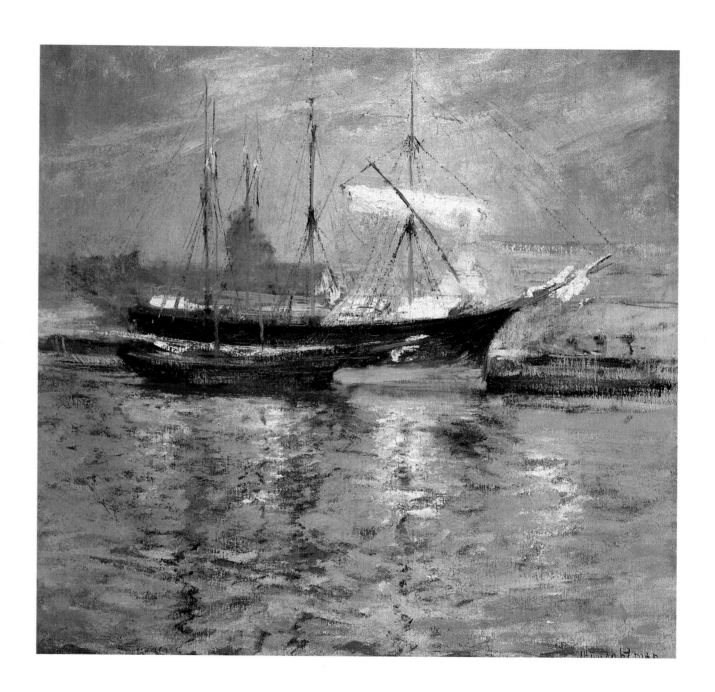

Plate 13

Fish Sheds and Schooner

Oil on canvas
25 × 30 in. (63.5 × 76.2 cm.)
Collection of the David Warner Foundation,
 Tuscaloosa, Alabama

Twachtman painted many of his more significant depictions of Gloucester from East Gloucester's Banner Hill. For *Fish Sheds and Schooner*, however, he chose to view his subject from an opposing vantage point. Standing on a Rocky Neck wharf, he painted the outstretched bay and shore beyond. The artist encompasses the entire expanse by means of various compositional devices: the shed in the foreground is shown as if seen through a wide-angle lens, while the diminished scale of the background structures suggests their distance. This radical foreshortening, used also in *Captain Bickford's Float* (Hale, fig. 1), allowed Twachtman to give the scene a sense of both immediacy and great depth. Yet, he cleverly achieves a closing of the spatial sweep by also devoting his attention to a schooner at rest in the center of the bay: its dark shape mediates between the dark edge of the shed in the foreground and the predominantly horizontal structures on the far hill. Twachtman expresses the varied visual rhythms in the landscape: the clashing bold foreground forms are answered by the more uniform background shapes which recede into the distance.

ALTERNATE TITLE: *Dock and Vessel*. Hale lists an unlocated painting entitled *Dock and Vessel* on p. 442, cat. no. 145, which seems to describe this work: "Painted summer, 1900. Descrip.: Covered wharf in right center foreground. Two masted ship in center middleground. Hill in background behind vessel."

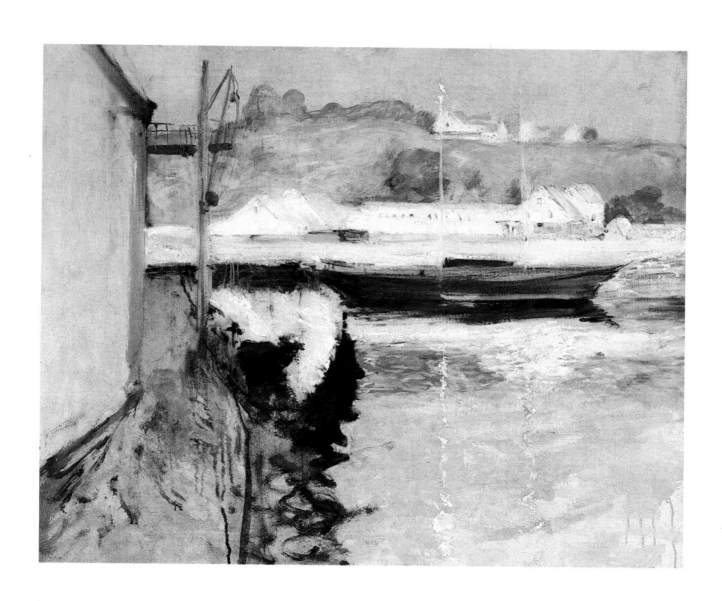

Plate 14

Beach at Squam

Oil on canvas
25 × 30 in. (34.3 × 24.1 cm.)
Signed lower left: *J. H. Twachtman*
Collection of Ira and Nancy Koger

The docks of Annisquam, Massachusetts which "once rang with the shoutings of busy fisher folk" were, by the turn of the century, "moss grown and in ruins,"[1] as the *Boston Globe* reported. However, by 1900, 'Squam (as the area was called by locals) had become a major gathering place for artists, who set up easels in front of its many picturesque sites. Twachtman does not hint of the social life in 'Squam in his view of one of its beaches, nor does he cast a nostalgic glance at his subject; instead he portrays its desolateness and quiet grandeur. He endows a small sand dune with the monumental strength an artist depicting western scenes might devote to a great natural wonder, presenting a broad view of the dune and its irregular mass with rich lavender tones. Through his paint handling and treatment of forms, Twachtman involves the viewer in the enveloping sensual experience offered by this site at the ocean's edge. A *New York Times* critic fittingly described *Beach at Squam* as "a bit of water and a sand dune rising to a knoll, and a sky streaked with clouds that arrest the attention as in nature they so often do."[2]

HALE: cat. A p. 541, no. 48; illus. p. 27, fig. 60; discussed p. 277.

PROVENANCE: Martha Twachtman (the artist's wife), Greenwich, Connecticut; Mr. and Mrs. John E. Cowdin, as of 1913; to [American Art Association, New York, 19 May 1915, cat. no. 73]; to [Macbeth Galleries, New York]; to Burton Mansfield, as of 1916; [American Art Association—Anderson Galleries, New York, *Mansfield Estate Sale*, 7 April 1933, cat. no. 73]; to [Macbeth Galleries]; to Edward Reiss, 1933; Charles F. Williams, as of 1937; to Mr. and Mrs. James R. Williams, Cincinnati, as of 1957; [Kraushaar Galleries, New York]; Chris Huntington, as of 1968; present coll., 1983.

EXHIBITIONS: Durand-Ruel Galleries, New York, 1901; School of Design for Women, New York, 1913, cat. no. 31 (as *Sand Dunes, Annisquam*, lent by John E. Cowdin, Esq.); Wadsworth Atheneum, Hartford, Connecticut, *Exhibition of Paintings, Pottery, and Glass Loaned by Hon. Burton Mansfield*, April 1920, cat. no. 31; Brooklyn Museum, New York, *Exhibition of Paintings by American Impressionists and Other Artists of the Period, 1880-1900*, 18 January-2 February 1932, cat. no. 107; Cincinnati Art Museum, *Paintings from the Collection of Mr. and Mrs. Charles Finn Williams*, 1 January-14 March 1937; Brooklyn Museum, New York, *The Coast and the Sea*, 19 November 1948-16 January 1949, cat. no. 118; Cincinnati, 1966, cat. no. 85; Ira Spanierman Gallery, New York, 1968, cat. no. 21 (lent by Chris Huntington); George D. and Harriet W. Cornell Fine Arts Center, Rollins College, Winter Park, Florida, *The Genteel Tradition: Impressionist and Realist Art from the Ira and Nancy Koger Collection in Celebration of the Centennial of Rollins College*, 1 November 1985-26 January 1986, pp. 72-73, illus.

REFERENCES: "A Trio of Painters," *New York Times*, 7 March 1901, p. 8; Eliot Clark, *John Twachtman*, (New York: Privately Published, 1924), illus. opp. p. 58.

[1] James J. Maginnis, "With the Artists at 'Squam," *Boston Globe*, 6 August 1900, p. 5. I wish to thank Professor William Gerdts for bringing this article to my attention.
[2] "A Trio of Painters," *New York Times*, 7 March 1901, p. 8.

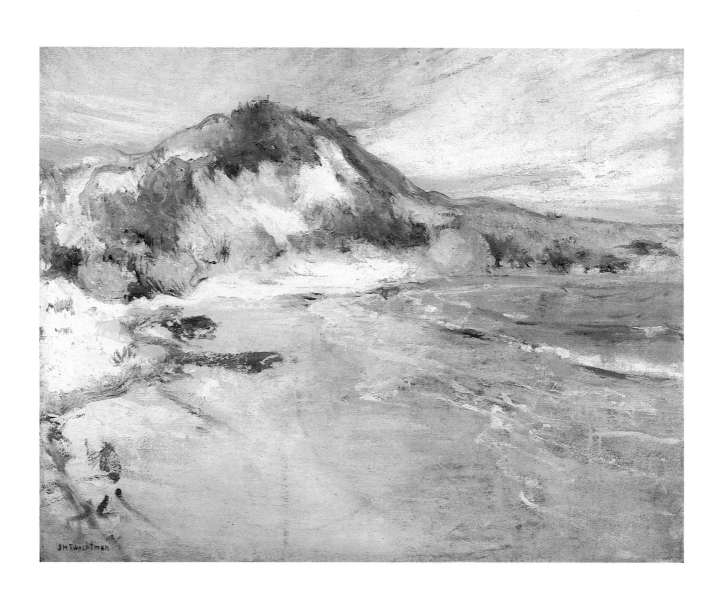

Plate 15

Landscape with Boat

Oil on panel
13½ × 9½ in. (34.2 × 24.1 cm.)
Stamped lower left in red: Twachtman Sale
(indicates painting was sold in
Twachtman's estate sale in 1903 at
American Art Galleries, New York)
Collection of Mr. and Mrs. Ralph Spencer,
New York

Twachtman explored the physicality of paint in his Gloucester paintings to a greater degree than he had previously. In *Landscape with Boat*, the substance of paint itself is an integral part of the image due to its vigorous and forceful application to the canvas. Twachtman was one of the first American artists to make use of a gestural style to add expression to his work, and he thus stands as a precursor to numerous painters of the mid-twentieth century, such as Jackson Pollock and Franz Kline. Although Twachtman's gestural manner was not recognized in his day, the difference between paintings of his Greenwich Period and those of his Gloucester Period was noticed by one critic who, in reviewing his 1901 Chicago exhibition, contrasted "delicate transient canvases such as *Spring*" with "strong, sparkling canvases [depicting] boats, swept with fleecy clouds, casting mottled shadows in the water's surface, the pink warehouses in the background furnishing delicious notes of color."[1] Eliot Clark, one of Twachtman's students, also observed how he had begun to describe landscape elements in abstract terms. Clark commented on Twachtman's tendency to dematerialize objects, writing that, "in experimenting with the unity of form and colour and their effective relations, the painter . . . neglected their content and significance otherwise In consequence there is little differentiation in substances and surface . . . in short those distinctions which are based upon the relativity of things and their impression upon the human mind. . . ."[2] In *Landscape with Boat*, Twachtman uses abstract forms to express his excitement about the scene: triangular shapes repeat and thus animate the composition, and the wharf in the foreground, by appearing to jut upward, directs the viewer's attention back into the three-dimensional space, while strips of color on the distant shore bring the background forward and thereby connect close and distant planes. Although Twachtman chose as his subjects sites in Gloucester that were typical and accessible, in painting them, he conveyed a fresh vision.

ALTERNATE TITLE: *Boat Landing*. The red stamp in the lower left of the canvas front indicates that the painting was sold in Twachtman's estate sale of 1903. Number 3 in the catalogue for the sale, "*Boat Landing* (14 × 10 in.)," appears to describe *Landscape with Boat*. Hale lists *Boat Landing* on p. 431, cat. no. 54a.

PROVENANCE: [American Art Galleries, New York, *Sale of the Work of the Late John H. Twachtman*, 24 March 1903, cat. no. 3, as *Boat Landing* (14 × 10 in)]; to Mrs. Marjorie Twachtman Pell (the artist's daughter), New Canaan, Connecticut, or Charles M. Kelly; [Sloan and Roman, New York]; to present coll., 1968.

[1] "Exhibitions of the Week," *Chicago Times Herald*, 30 December 1901, unpaginated newspaper clipping, Scrapbook 13, pp. 98-99, Ryerson Library, Art Institute of Chicago.
[2] Clark, "The Art of John Twachtman," p. lxxxi.

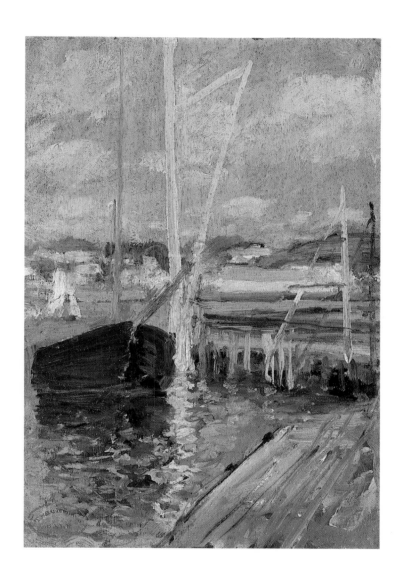

Plate 16

Aboard a Steamer

Oil on panel
14½ × 9½ in. (36.8 × 24.1 cm.)
Collection of the Kennedy Galleries,
 New York

Twachtman actively sought out industrial subjects in Gloucester, painting scenes on the coal wharves and sketching barges and derricks.[1] The steamer, represented in this painting, also inspired him to a new mode of expression, one consistent with his modern subject. By depicting the steamer close-up and setting out its open deck in the foreground, Twachtman urges the viewer to enter into the experience. His handling is rough, with paint dashed quickly onto his panel. Forms are treated abstractly, as seemingly-detached pieces of a disconnected pattern, thus communicating the ship's motion. Although painters such as George Inness had depicted trains passing through the wilderness, Twachtman was one of the first American painters to express the energy and grit of modern life, laying the groundwork for artists who took up industrial subjects later in the twentieth century.

PROVENANCE: Martha Twachtman (the artist's wife), Greenwich, Connecticut; Quentin Twachtman (the artist's son), until 1953; Charlotte Twachtman (Mrs. P. M. Soutter), Phyllis Twachtman, and John Twachtman (children of Quentin Twachtman), until 1975; to present coll., 1975.

[1] See Hale cat. nos. 36, 37, 693; and *Gloucester Dock* (pl. 4 in this catalogue).

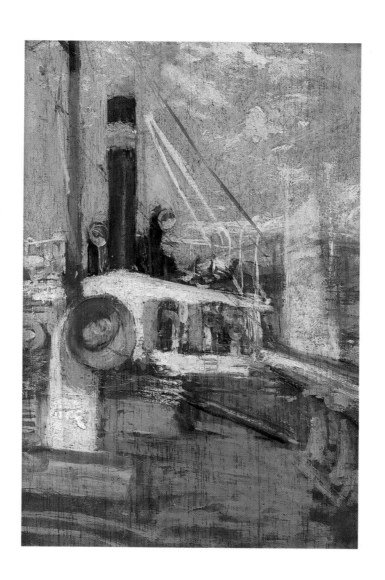

Plate 17

My Autumn Studio

Oil on canvas
30 × 30 in. (76.2 × 76.2 cm.)
Stamped lower left in red: *Twachtman Sale*
 (indicates painting was sold in
 Twachtman's estate sale in 1903 at
 American Art Galleries, New York)
Phillips Collection, Washington, D.C.

Duncan Phillips, who collected a number of Twachtman's works (including *My Autumn Studio*, acquired in 1919), wrote that the artist's designs were "by turns elaborate and austere. His art was alternately of the most delicate, far-sought 'nuance' and of the most refreshing spontaneity—giving a sense of musical improvisation."[1] Twachtman's *My Autumn Studio* represents the spontaneous side of his work. As Hale has pointed out, the painting reveals the artist's "unconscious sense of abstract design that dictated the curving rhythms and the ordering of the strokes into patterns independent of, but not in opposition to, the objects in the picture."[2] Working freely, Twachtman seems to use his brush and paint as a means of making contact with varied natural forms, while with the irregular, weaving pattern of the composition, gaining control over the scene.

ALTERNATE TITLE: *My Summer Studio*. When first exhibited in 1901, this work was listed as *My Summer Studio*, a title that was retained until c. 1920, at which time it was changed to *My Autumn Studio*, probably by Duncan Phillips. The autumnal colors in the painting may have prompted Phillips to make this change, although the Gloucester landscape is known to appear fall-like in late summer as well. Since Twachtman was in Gloucester through early September in 1900, it is possible that this painting depicts a studio where he worked, perhaps located in the vicinity of the Rockaway Hotel on Rocky Neck (see Boyle, fig. 4), although the small structure resembles Twachtman's last studio, which adjoined the Harbor View Hotel (see Boyle, fig. 6).

HALE: cat. A p. 571, no. 602 (as *My Summer Studio*); illus., p. 216, fig. 29; discussed pp. 215, 220.

PROVENANCE: [American Art Galleries, New York, *Sale of the Work of the Late John H. Twachtman*, 19 March 1903, cat. no. 18, as *My Summer Studio*]; to Cottier & Co., New York; Mrs. John E. Cowdin; Alexander Morten; to [American Art Association, New York, *91 Paintings from the Collections of Alexander Morten, Frank R. Lawrence, and James S. Inglis*, 29 May 1919, cat. no. 80, as *My Summer Studio*]; to [Kraushaar Galleries, New York]; to present coll., 1919.

EXHIBITIONS: Cincinnati, 1901, cat. no. 33 (as *My Summer Studio*); Lotos Club, New York, 1907, cat. no. 6 (as *My Summer Studio*); Knoedler Galleries, New York, *Fourteenth Annual Summer Exhibition of American Artists*, 1920, cat. no. 28 (as *My Summer Studio*); Phillips Collection, Washington, D.C., *Paintings by Twachtman, Weir, and Lawson*, July-October 1953; American Arts Alliance, Arkansas Art Center, Little Rock, *American Impressionist Paintings from the Phillips Collection*, traveling exhibition (Oklahoma Art Center, Oklahoma City; Museum of Art and Archaeology; University of Mississippi, Columbia; Sheldon Memorial Art Gallery, University of Nebraska, Lincoln; Charles H. Macnider Museum, Mason City, Iowa; Lakeview Museum of Arts and Science, Peoria, Illinois; Philbrook Art Center, Tulsa, Oakhoma; Federal Reserve Bank, Kansas City, Missouri), September 1985-December 1986.

REFERENCES: "Twachtman Picture Sale," *New York Times*, 25 March 1903, p. 5; *American Art Annual* 16 (New York: American Federation of Arts, 1903), p. 58; *Phillips Collection Catalogue* (New York: Thames and Hudson, 1952), p. 102.

[1] Duncan Phillips, "Twachtman—An Appreciation," *International Studio* 72 (February 1919): cvi.
[2] Hale, *Life and Creative Development*, p. 220.

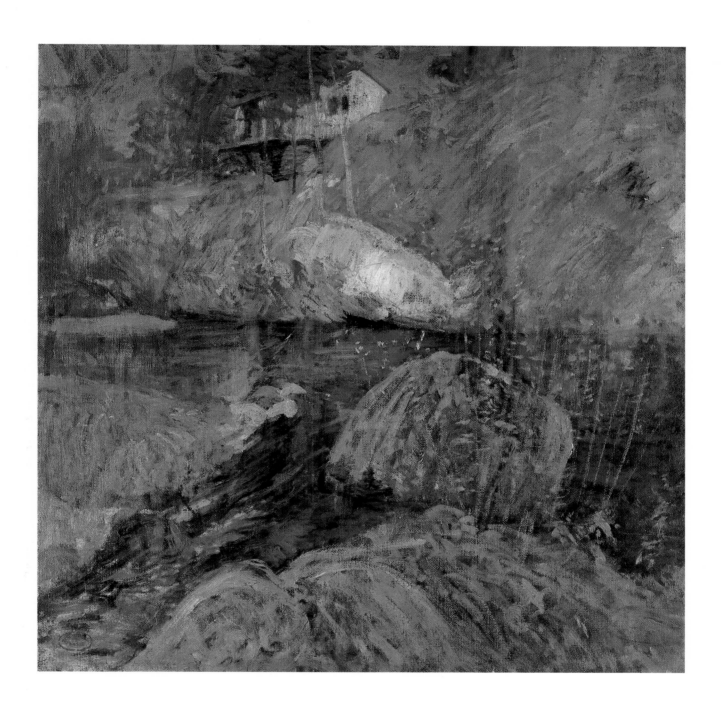

Plate 18

Gloucester, Fishermen's Houses

Oil on canvas
25 × 25½ in. (63.5 × 64.8 cm.)
Collection of Rita and Daniel Fraad

The composition of *Gloucester, Fishermen's Houses* is extremely simplified, even in comparison with Twachtman's other Gloucester paintings. The large houses just across a road seem to be located in real space rather than contained in a picture. They even appear to extend beyond the frame, which heightens the illusion. Rather than depicting his subject realistically, the artist conveys the powerful sensation he received from his encounter with it, painting with a bold palette of bright pinks and lavenders with touches of green and brown. Twachtman went beyond an Impressionist depiction with this work, endowing the humble fishermen's houses with the full strength of his subjective experience.

ALTERNATE TITLE: *Red House*. Hale's catalogue listing for *Red House* on p. 461, no. 307 (25 × 25 in., painted 1900) may describe *Gloucester, Fishermen's Houses*: "houses in middle foreground, steps on right side. No trees. Immediate foreground perhaps water. This is one of the Gloucester paintings seen only as thumbnail sketch by artist after original work. Title by Twachtman."

PROVENANCE: Mr. and Mrs. Godfrey Twachtman, Independence, Missouri (Godfrey Twachtman was the artist's son); [Ira Spanierman Gallery, New York, 1967]; to present coll., 1967.

EXHIBITIONS: Cincinnati, 1966, cat. no. 86 (lent by Mr. and Mrs. Godfrey Twachtman); Ira Spanierman Gallery, New York, cat. no. 24; Amon Carter Museum, Fort Worth, Texas, *American Paintings, Watercolors, and Drawings from the Collection of Rita and Daniel Fraad*, 24 May-14 July 1985, cat. no. 20, illus.

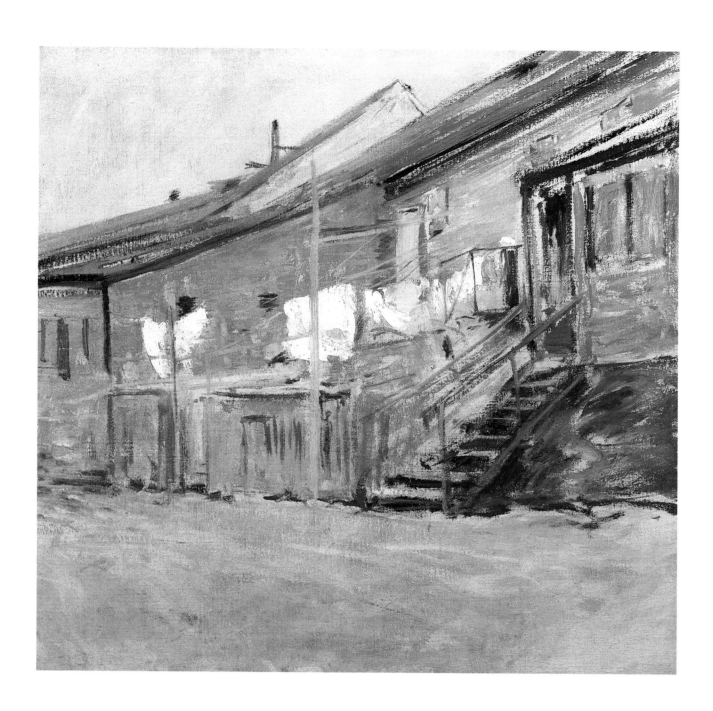

Plate 19

Harbor View Hotel

Oil on canvas
30 × 30 in. (76.2 × 76.2 cm.)
Collection of the Nelson-Atkins Museum of
 Art, Kansas City, Missouri

The Harbor View was one of Gloucester's most famous resort hotels for both visitors and summer residents in the early twentieth century. It was located just beyond Rocky Neck on Gloucester's Eastern Shore, in an area described by one author in 1897 as a "land of rackets and golf clubs, summer girls, novels, and hammocks, water-color kits and white umbrellas."[1] Twachtman's painting of the hotel seems a far cry from this description. The foreground space is empty and quiet, and behind it the hotel blends with the atmospheric distance. The canvas is dominated by a diamond-shaped arrangement of posts, one corner of which occurs at a large spreading elm, whose fanlike form arrests the eye and counters the movement suggested by the diagonals of the piers. As Richard Boyle has written, although the work is unfinished, "the quality of [Twachtman's] pictorial structure—the underpinning, so to speak— is very much in evidence here."[2] Perhaps aware of the shortness of the time left him, the artist blocked his forms in broadly, by now able to quickly express his ideas "both as to significant masses and color, with the first few strokes of the long bristle brushes that he preferred."[3] During the last years of his life, Twachtman cast off his Greenwich Period technique of applying paint laboriously and, with a minimum of means, attained a clear and direct expression in which his outer and inner visions coalesced.

HALE: cat. A p. 554, no. 282; illus. p. 297, fig. 65; discussed p. 289.

PROVENANCE: J. Alden Twachtman (the artist's son), Greenwich, Connecticut; to present coll., 1933.

EXHIBITIONS: School of Design for Women, New York, 1913, cat. no.16 (as *The Last Canvas*, lent by Mrs. J. H. Twachtman); Palace of the Fine Arts, San Francisco, *Panama-Pacific International Exposition*, 1915, cat. no. 4076; Brooklyn Museum, New York, *Leaders of American Impressionism*, 15 October-28 November 1937.

REFERENCES: "Twachtman's Last Picture for Kansas City," *Art Digest* 7 (1 May 1933): 18, illus.; Richard Boyle, *John Twachtman* (New York: Watson-Guptill Publications, 1979), pp. 84-85, illus. pl. 32; ———, "John Henry Twachtman: Tone Poems on Canvas," *Antiques World* (December 1980): 67, illus.; William H. Gerdts, *American Impressionism* (New York: Abbeville, 1984), p. 192, illus. pl. 214.

[1] Edmund Garrett, *Romance and Reality of the Puritan Coast* (Boston: Little Brown, 1897), p. 185.
[2] Boyle, *John Twachtman* (New York: Watson-Guptill Publications, 1979), p. 84.
[3] Hale, *Life and Creative Development*, p. 289.

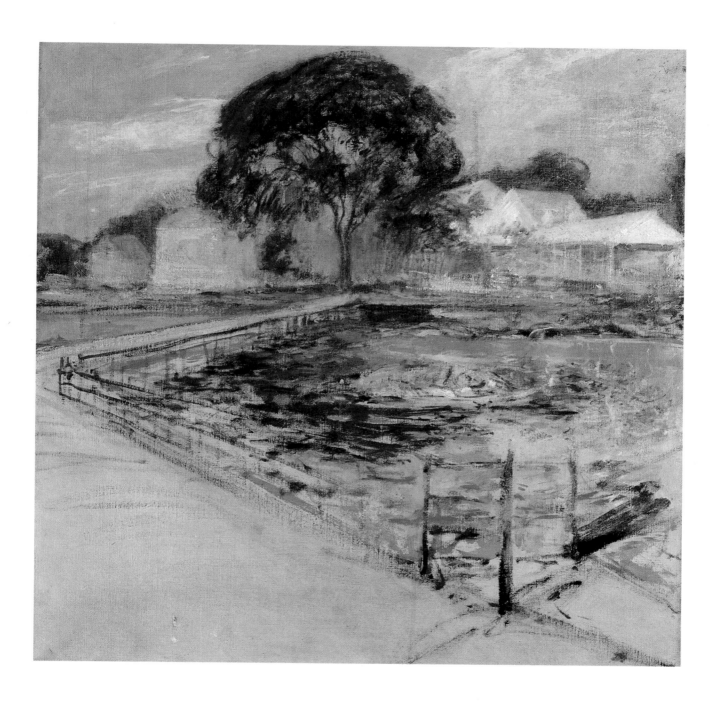

Index to Reproductions

Buhler, Augustus W.
 Hauling the Trawl, p. 41
Churchill, Alfred Vance
 Untitled (Rockport Harbor I), p. 36
Clark, Eliot
 Under the Wharf, Gloucester, p. 40
Corwin, Charles Abel
 Ten Pound Island, p. 36
Coxe, Reginald
 Seascape, p. 30
Dean, Walter
 Untitled (View of Gloucester Harbor), p. 31
DeCamp, Joseph
 Gloucester, p. 34
 Little Hotel, The, p. 42
Duveneck, Frank
 Gloucester Pier, p. 33
Farrell, Katherine Levin
 Gloucester Harbor, p. 38
Fauley, Albert C.
 Sail Boat, p. 37
Hazard, Arthur Merton
 Gloucester Scene, pp. 26, 37
Hunt, William Morris
 Gloucester Harbor, p. 28
Potthast, Edward
 Gloucester, p. 35
Twachtman, John Henry
 Aboard a Steamer, p. 81
 Bark and Schooner (Italian Salt Bark), p. 73
 Beach at Squam, p. 77
 Boats in Harbor, p. 65
 Captain Bickford's Float, p. 12
 Drying Sails, pp. 10, 13
 End of the Rain, The, p. 67
 Fish Sheds and Schooner, p. 75
 Fishing Boats at Gloucester, p. 51
 Gloucester, p. 69
 Gloucester Coast (Eastern Shore of Cape Ann, Mass.), p. 18
 Gloucester Dock, p. 57
 Gloucester, Fishermen's Houses, p. 85
 Gloucester Harbor, p. 59
 Harbor View Hotel, p. 87
 Landscape with Boat, p. 79
 Little Giant, p. 63
 My Autumn Studio, p. 83
 Reflections, p. 55
 View from East Gloucester, p. 61
 Waterfront Scene—Gloucester, p. 53
 Wild Cherry Tree, p. 71

Photographs:
Cape Ann Historical Association, p. 41
Gale Farley, p. 59
R. H. Love Galleries, p. 40
National Museum of American Art,
 Smithsonian Institution, p. 24
Princeton University Library, p. 19
Ryerson Library, Art Institute of Chicago, p. 36
Herman Spooner, p. 22

Design:
Marcus Ratliff Inc., New York
Typesetting:
Trufont Typographers, Inc., New York
Color plates, printing and binding:
South Sea International Press, Hong Kong